The ESSEN [barcode D0006466] f

ART HISTORY

George M. Cohen, Ph.D.
Professor of Art History
Hofstra University, Hempstead, NY

Research and Education Association
61 Ethel Road West
Piscataway, New Jersey 08854

THE ESSENTIALS ®
OF ART HISTORY

Printed in the United States of America

Library of Congress Catalog Card Number 95-71344

International Standard Book Number 0-87891-792-6

ESSENTIALS is a registered trademark of
Research & Education Association, Piscataway, New Jersey 08854

WHAT "THE ESSENTIALS" WILL DO FOR YOU

This book is a review and study guide. It is comprehensive and it is concise.

It helps in preparing for exams, in doing homework, and remains a handy reference source at all times.

It condenses the vast amount of detail characteristic of the subject matter and summarizes the **essentials** of the field.

It will thus save hours of study and preparation time.

The book provides quick access to the important principles, concepts, practices, and definitions in the field.

Materials needed for exams can be reviewed in summary form – eliminating the need to read and reread many pages of textbook and class notes. The summaries will even tend to bring detail to mind that had been previously read or noted.

This "ESSENTIALS" book has been prepared by an expert in the field, and has been carefully reviewed to assure accuracy and maximum usefulness.

Dr. Max Fogiel
Program Director

CONTENTS

Chapter 5
GREEK (HELLENIC) ART

Chapter 6
ETRUSCAN ART

Chapter 7
ROMAN ART

Chapter 8
EARLY CHRISTIAN ART

vi

Chapter 11
THE BAROQUE PERIOD

Chapter 12
NINETEENTH CENTURY ART

Chapter 13
TWENTIETH CENTURY ART TO *CA.* 1950

Chapter 14
POST-MODERN ART: *CA*. 1950 TO THE PRESENT

CHAPTER 1

Prehistoric Art

1.1 The Paleolithic Period

1.1.1 Paleolithic Architecture

The earliest "buildings" were natural caves which served as shelters from bad weather and places where ritualistic tribal rites were conducted.

Huts fashioned of mud (adobe), thatch and/or animal skins were found in Europe and South Africa.

1.1.2 Paleolithic Sculpture and Painting

Ten characteristics define cave art:

1. Portrayal of the unseen – The animal was remembered by the cave man and then drawn, painted and/or carved on the cave wall or floor.

2. A distortion of perspective – This was indicated by an overlapping of figures which showed no concern for a three-dimensional perspective.

3. Horror vacui – The cave man feared an empty expanse of wall space. He thought an empty space was a place where evil spirits dwelt; therefore, he filled in as much of the wall area as possible.

1

4. Readability – The representation can immediately be recognized as a specific animal, human, etc. There was no chance for error in distinguishing what the image portrayed actually was.

5. Condensation or stylization – The cave man reduced the image into its most essential aspect; he eliminated details and concentrated on over-all generalities of the form represented.

6. Distortion or over-emphasis – The cave man distorted or over-emphasized the beast in order to show the fleshy parts to be eaten. Sometimes, the form was revealed as pregnant to insure "magically" more of the species to come.

7. Outlining with a heavy linear contour – This was done to distinguish the species and separate or isolate it for the "kill."

8. Symmetry or balance – Balance was shown in the arrangement of the animals on the wall surface. Masses or groups of configurations would be equally painted or carved into herds of approximately the same number, but not the same size.

9. Rhythm and repetition – The cave man enjoyed representing a fluid motion within his forms. Simply speaking, the more an image was portrayed, the more assurance the cave man felt in finding food for his family. He repeated images in order to insure a "kill."

10. Restricted originality – A standard or norm was used for specific beasts. This revealed that the cave man was not only too superstitious to change the style of his forms, but was somewhat unoriginal as well. However, this lack of originality is of psychological rather than aesthetic importance, for the cave man felt that if an image, carved or painted, was "killed" magically in the cave and then in reality slain outside the cave, there would be no reason to change the manner of portraying it. If a style worked (magically "killed" the beast inside the cave and actually killed it outside the cave), they would rather keep it than change its style for "art's sake."

The most noted cave art came from the Magdelenian Period or late Paleolithic Period. The noted cities were: Altamira, Spain (found

in 1879); Lascaux (Dordogne), France (found in 1940); and Chauvert, France (found in 1995).

Vegetable dyes, animal oils, and colored earthen minerals were used for painted images. While sculpture, in the round and relief, was fashioned from soft clay and hardened on the walls and floor of the cave.

1.2 The Neolithic Period

1.2.1 Neolithic Architecture

A change occurred from the nomadic, hunting and gathering of the Paleolithic Period. The Neolithic people lived in settled villages and developed a food-producing domestic economy.

Stone houses and adobe sanctuaries with plaster floors were found at Jericho, Jordan between 7,000 and 6,000 B.C. Later, the stone walls and towers were built in the Near East. Also, at Carna, France (*ca.* 1,500 B.C.) and Stonehenge, England (*ca.* 2,000 B.C.) "megalithic" structures (dolmens, menhirs, sarsens, trilithons, etc., were built for religious purposes.

1.2.2 Neolithic Sculpture and Painting

"Reconstituted" skulls made of plaster and inlaid shells for eyes were unearthed at Jericho. Fertility images of both sexes were found at Malta (*ca.* 1,500 B.C.)

In painting, with an increased interest in husbandry, there was perhaps less time to create images on cave walls and what themes were drawn appeared more sketchy, stiff, and looked stick-like.

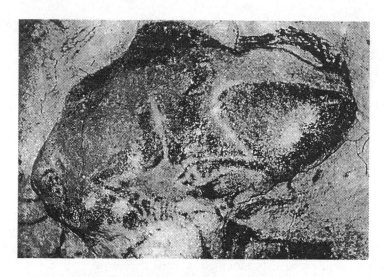

OLD STONE AGE: *Wounded Bison*, artist unknown, 15,000–10,000 B.C. Cave painting. Altamira, Spain.

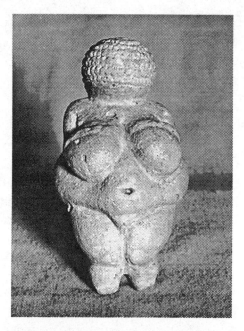

OLD STONE AGE: *Venus of Willendorf*, artist unknown, 15,000–10,000 B.C. Statue. Museum of Natural History, Vienna.

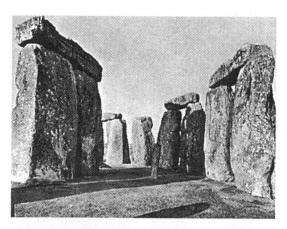

NEW STONE AGE: *Stonehenge*, artist unknown, 1,800–1,400 B.C. Salisbury Plain, Wiltshire, England.

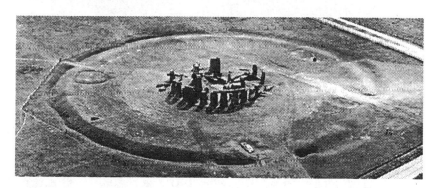

NEW STONE AGE: *The Great Circle*, artist unknown, 1,800–1,400 B.C. Salisbury Plain, Wiltshire, England.

CHAPTER 2

Egyptian Art

2.1 Origins

There were many periods that revealed the complex drama of Ancient Egyptian art. Each epoch had its individual style, yet, there was an over-all homogeneity that ran throughout Egyptian culture.

The following is a list of the more important stylistic/historical periods of Egyptian art and culture:

1. Prehistoric–Predynastic Period, from the beginnings to Early Dynastic (*ca.* 4,000–3,200 B.C.).

2. The Archaic Period, Dynasties I–III (*ca.* 3,200–2,680 B.C.).

3. The Old Kingdom, Dynasties III–VI (*ca.* 2,680–2,258 B.C.).

4. The Middle Kingdom, Dynasties XI–XII (*ca.* 2,040–1,786 B.C.).

5. The New Kingdom or Empire Period, Dynasties XVIII–XX (*ca.* 1,570–1,085 B.C.).

From Prehistoric times until the rise of the New Kingdom, Egyptian civilization was almost completely cut off from other countries. In fact, the Egyptians believed that nothing but space existed beyond the mountains and deserts to either side of the Nile River. Thus, because of the desert to the east, west, and south, Egypt was at first

an isolated country, relatively untouched by outside artistic or political influence. However, this changed when Egypt was overrun by foreign invaders from Persia, Mesopotamia, Asia Minor, and later, Greece.

Egyptian art was inevitably affected by geography and climate. There was little rain in Egypt. When the monsoon period came, the Nile River overflowed onto a narrow fertile strip along its banks. It was there that the first Egyptians subsisted. As a result of these yearly inundation's, thousands were made homeless and thereby had to work for the pharaoh (ruler) for board and lodging. This gave the pharaohs an inexhaustible supply of labor with which to build their monuments. Perhaps, in this sense, they became civilization's first "indentured servants."

Religion dominated the direction of Egyptian art. The pharaoh's deification and the belief in many animal gods made up Egypt's pantheon.

Egyptian art had a utilitarian rather than a purely aesthetic function. All artisans worked toward a common and universal goal, that is, to ensure immortality for their rulers and families.

2.2 Egyptian Architecture

There existed an abundance of building materials: clay, limestone, granite, porphyry, basalt, etc.

Temples and tombs were the most important buildings and served as eternal abodes for the Egyptian "soul" in the hereafter. The quest was to supply the so-called Ka, the immortal ghost, with a resting place.

The earliest tombs, from the Archaic Period, were called Mastabas. There followed in the Old Kingdom in the pyramid style. By the Middle and New Kingdoms, there arose the mortuary temple tomb and finally the cult temple.

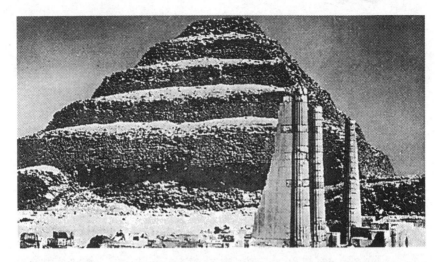

THE OLD KINGDOM, DYNASTIES III–VI: *Step Pyramid*, Imhotep, 2,650 B.C. Cut stone. Saqqara, Egypt.

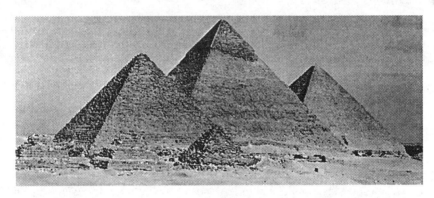

THE OLD KINGDOM DYNASTIES III–VI: *Pyramids of Mycerinus: Chefren and Cehpos*, artist unknown, Chefren (2,470 B.C.), Chepos (2,530 B.C.).

2.3 Egyptian Sculpture

Free-standing and bas-relief sculptures were made. These became "houses" or shelters for the Ka in the afterlife.

Free-standing images followed the Law of Frontality (the best view of the image was from the front). While bas-relief figures adhered to the Law of Conceptuality (the most significant parts of anatomy were shown most directly, that is, head in profile, eye and torso frontal and from the waist to the feet in profile).

2.4 Egyptian Painting

Paintings adorned tombs and temples. There developed a system of painting on stucco, an early form of fresco art, called *buon* fresco.

The Law of Conceptuality was followed. Images ranged from the religious to the everyday (or genre types). The method of painting was in horizontal "registers" across the wall surface.

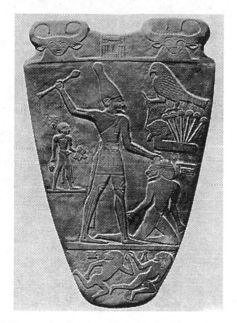

THE ARCHAIC PERIOD DYNASTIES I–III: *Palette of King Narmer*, **artist unknown, 3,000 B.C. Slatestone. Egyptian Museum, Cairo.**

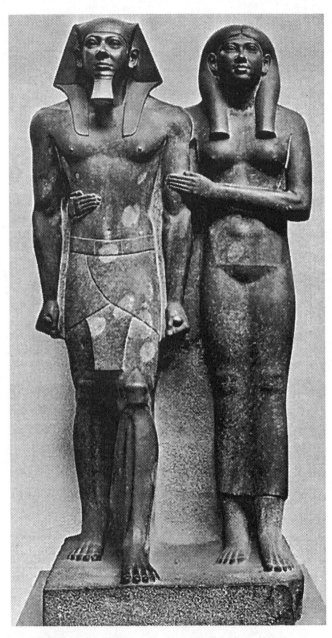

THE OLD KINGDOM DYNASTIES I–III: *Mycerinus and his Queen,* artist unknown, 2,500 B.C. Slate. Museum of Fine Arts, Boston.

CHAPTER 3

Mesopotamian Art

3.1 Origins

There were many periods that made up the art of Mesopotamia. The more important were:

1. The Sumerian Period, 3,500–2,500 B.C.

2. The Akkadian Period, 2,350–2,180 B.C.

3. The Neo-Sumerian Period, 2,125–2,025 B.C.

4. The Assyrian Period, 1,000 – 612 B.C.

5. The Babylonian Period, 1,900–1,600 B.C.

6. The Neo-Babylonian Period, 612–539 B.C.

Mesopotamia, meaning "the land between two rivers" (Tigris and Euphrates), was a strip of fertile land surrounded by the Syrian and Arabian deserts to the southwest and the Zagros Mountains to the northeast. It was a fertile land open to invasion by barbarians from the north and by neighboring Semites. As a result, its people conceived their art around the concept of war.

Its society was agrarian whose people lived in city-states. The land was governed by kings. Priests were part of the religious hierarchy and took charge of the temples and civic duties.

3.2 Sumerian Art

The Sumerians settled in eastern Mesopotamia before 4,000 B.C. They believed in an afterlife and developed phonetic writing, known as cuneiform.

Their art centered around temples, called Ziggurats. Later, the cities of Telloh-Lagash and Ur showed rebuilt temples and free-standing sculpture depicting their rulers. Painting was not expressed here.

The Akkadians took the Sumerian tongue and traditions. Their temples imitated the Sumerians. They were also known for their excellent metalwork.

3.2.1 Sumerian Architecture

The Sumerians built elaborate palaces with rectangular rooms asymmetrically placed around open courtyards. "Streets of the Dead" served as cemeteries. Kings were usually buried in subterranean vaults.

3.2.2 Sumerian Sculpture

Sumerian free-standing sculpture abides by the Law of Frontality. Their sculpture was smaller-in-scale and more cylindrical than Egyptian forms. Limestone and polished basalt (or diorite) were used.

Sumerian reliefs were freer and less traditional than Egyptian. Victory steles were popular and followed the Law of Conceptuality similar to Egyptian reliefs. Rulers were heroized as they vanquished their foes.

3.3 Assyrian Art

Before 2,000 B.C., Assyrian art was similar in style to that of the Sumerians to the south. After 2,000 B.C., Assyrian art developed an individual manner, yet it still remained linked to the Near Eastern expression of formality and stylization.

3.3.1 Assyrian Architecture

Ziggurats and palaces were built on citadels and surrounded by thick walls made of stones. They were laid out on a "grid-plan"

(streets crossing at right angles) and had courtyards and rectangular rooms. The top levels of the ziggurats were astrological observations and military outposts. The palaces venerated and glorified the kings.

Palace walls were veneered with glazed tiles and painted reliefs. These told of historical events and battles.

There were gateways into the palaces protected by winged guardian beasts with five-legs.

3.3.2 Assyrian Sculpture and Painting

Assyrian sculpture was in-the-round and in relief. Rulers, deities, and larger-than-life guardian figures were made of imported limestone and basalt from the far-off Zagros Mountains. Carved and inlaid scenes of battles, tribute-bearing worshippers, and hunting scenes decorated the palace walls. Some fresco work was done. Its style echoed relief work.

3.4 Babylonian Art

The Babylonian's art mirrored Sumerian art. This was because of the proximity and inter-cultural religious activity with the Sumerians.

3.4.1 Babylonian Architecture

Babylonian architecture revealed huge adobe religious and civic structures. Palaces and ziggurats were decorated with colored glazed brick tiles and reliefs. Royal processional ways and ornate gateways as well as multi-colored ziggurats were dominant. Most palaces were surrounded by thick walls.

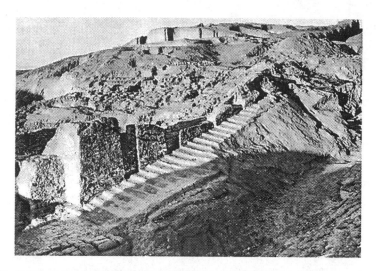

THE SUMERIAN PERIOD: *The White Temple*, artist unknown, 3,500–3,000 B.C. Warka.

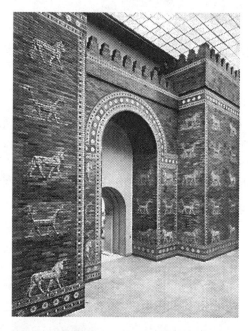

THE NEO-BABYLONIAN PERIOD: *The Ishtar Gate*, artist unknown, 575 B.C. State Museum, East Berlin.

14

3.4.2 Babylonian Sculpture

The Babylonians created some free-standing and relief sculpture. The style echoed the Sumerian's but was less detailed in design. Imported limestone and basalt were used to commemorate rulers, deities and law code reliefs. Less popular were battle scenes, tribute-bearers, and hunting themes.

Fresco work was not used.

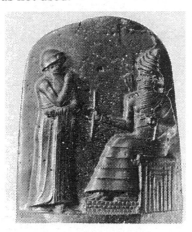

THE BABYLONIAN PERIOD: *Law Code of Hammurabi*, **artist unknown, 1,760 B.C. Stone slab. The Louvre, Paris.**

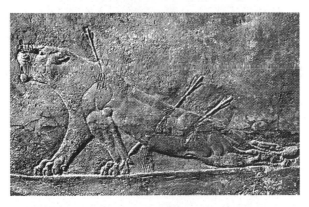

THE BABYLONIAN PERIOD: *Dying Lioness*, **artist unknown, 650 B.C. Slab sculpture. British Museum, London.**

CHAPTER 4

Pre-Hellenic (Aegean) Art

4.1 Origins

Known as Aegean Art, pre-Hellenic Art had three major art cultures:

1. The Cycladic or Early Minoan Period, *ca.* 2,800–2,000 B.C.

2. The Minoan Period, *ca.* 2,000–1,400 B.C.

3. The Mycenaean Period, *ca.* 1,500–1,100 B.C.

The Cycladic and Minoan periods ended with either natural destruction by earthquakes or invasions by barbarians from the North, known as the Dorians.

4.2 Cycladic Art

Cycladic art arose from a group of islands in the Aegean Sea, southwest of Attica. The most noted islands were: Melos, Naxos, Tenos, Paros, and Andros.

Little cycladic architecture was found aside from rock-cut tombs.

Cycladic sculpture abounded. They buried marble idols with their dead. These figures appeared as standing male and female forms with arms folded and in the shape of "fiddles" or "planks." The females, most common, personified the Mother Goddess of Fertility. The males

also referred to fertility. Both sexes were stiff, flat, angular, and wedge-shaped, they had columnar necks and tilted oval faces with no features other than a long ridge-like nose. They ranged from a few inches to life-size. Among them some musician figures were made.

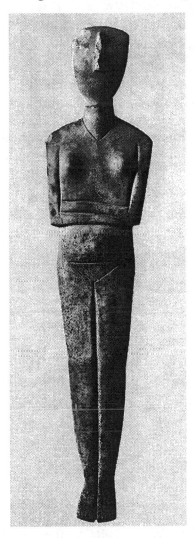

CYCLADIC OR EARLY MINOAN PERIOD: *Cycladic Idol from Amorgos*, artist unknown, 2,500–1,100 B.C. Marble. Ashmolean Museum, Oxford.

4.3 Minoan Art

The Minoan civilization arose about 2,000 B.C. Its people were said to have come from Asia Minor. The Minoan culture reached its height between 1,600 and 1,400 B.C. This was the time when the great palaces were built. Chief sites were Knossos and Phaestos.

The Minoans were, for the most part, a peace-loving nation. They developed a unique export–import trade with the Egyptians and other countries in the Mediterranean area. It has been said that they even imported slaves from other lands (especially Africa) as evidenced by many of the mural paintings that adorned palace interiors. In the event of war, they had a large navy, and because of the security provided by this powerful navy, Minoan palaces were not fortified.

The Minoans were athletically conscious, too. Track meets and bull-leaping feats were quite common and often depicted in fresco on the palace walls. Athletic events were bound up with religion. To please the "pantheon" (gods) a Minoan citizen had to exhibit athletic competence and prowess.

The Minoan religion, like most ancient religions, was pantheistic (devoted to many gods). The most important image worshipped was the snake goddess. There was even a shrine-room set aside for her in each palace. Also of importance was the dove, which quite often had a room in a palace for worship. The sign of the double-ax was considered sacred and imbued with ultra-magical powers. It usually was a symbol of life similar to the Egyptian ankh.

A priest-king ruled the land assisted by priests who performed and participated in religious ceremonies. The priest-king was a merchant and entrepreneur as well as a demi-god. He was in charge of the commerce of Crete whose economy depended on trade with foreign lands.

4.3.1 Minoan Architecture

The Minoans were great architectural engineers. They developed a system of plumbing, had irrigation, and built subterranean rooms for their palaces.

Palaces, without walls surrounding and seaport structures were the most common form of architecture. A few temple tombs have been found.

Because of their Asiatic heritage, Minoan buildings had flat roofs. They used rubble, wood, sun-dried brick, and gypsum for construction. Roof deckings had round logs for support. Palace interior walls were stuccoed and painted with frescoes.

The Minoans had light wells to illuminate underground chambers. They had stairways, storage rooms, courtyards for athletic events, and pools for bathing. They conceived the Megaron or private queen's chamber (which later became the proto-type for the Greek temple). Lastly, they created a unique column type with the shaft of the column tapered at the bottom rather than the top. They developed the Doric Order with an abacus (or block) placed atop an echinus (or cushion) member. Column shafts were made of cypress.

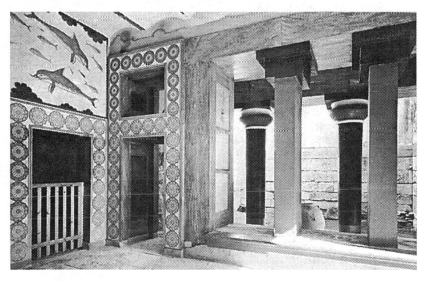

MYCENAEAN PERIOD: *Queens Chambers*, **artist unknown, 1,500 B.C. Sun-dried brick. Knossos, Crete.**

4.3.2 Minoan Sculpture

Minoan sculpture was small and portable. Figures, made of terra-cotta (faience), ivory, and gold or steatite, were in-the-round. There was some relief work, usually of a decorative variety that appeared stylized, geometric in shape with patterns from the flora and fauna world.

The most popular themes were the snake goddess, athletes jumping, and bulls' heads.

4.3.3 Minoan Painting

Colorful frescoes (buon or true frescoes) adorned the interiors and exteriors of palace walls. Their subject matter ranged from the portrayal of the king to bulls leaping or sea piece themes.

Technically, they used a linear manner similar to the Egyptians. Males were dark red; females were painted white or passive yellow. The Law of Conceptuality was followed. They displayed nipped-in waists and the females had large breasts and hips to emphasize their magical, fecund powers.

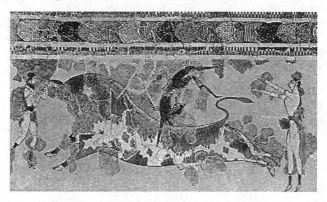

MYCENAEAN PERIOD: *Toreador Fresco*, **artist unknown, 1,500 B.C. Mural. Archaeological Museum, Heraklion, Crete.**

The Minoans developed a love for decoration. Abstract, rhythmic, flowing, geometric patterns, and swirl-motifs were used. These echoed the movement of the sea and its tides. In addition, a shield or "figure-eight" design was found.

All themes appeared two-dimensional and flat.

4.3.4 Minoan Minor Art

At the head of Minoan art was the craft of pottery-making. The Minoans invented the potter's wheel around 1,600 B.C. As a result, many pottery shapes and designs were conceived. Pottery was decorated in either naturalistic (the octopus style was a favorite) or geometric, Kamares and the Palace Style patterns.

4.4 Mycenaean Art

The Mycenaen period was the early art of the Greek mainland before the Greeks arrived. It was also called the Late Helladic period.

The height of this culture lasted from 1,400 to 1,100 B.C. Most of the artistic activity occurred on the southeast coast of Greece. The chief sites were Mycenae and Tiryns.

Mycenaean art mirrored Minoan. However, they were not related to the Minoans and were said to have migrated into Greece from the north.

They were more war-like than the Minoans. Their cities were built on high citadels, walled-in and heavily fortified. About 1,100 B.C., the Dorians overran Greece and ended the civilization.

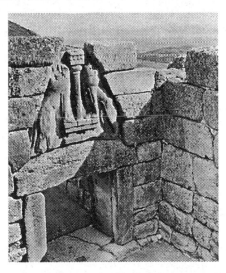

THE MYCENAEAN PERIOD: *The Lion Gate*, **artist unknown, 1,250 B.C. Stone block. Mycenae.**

21

4.4.1 Mycenaean Architecture

The Mycenaeans had fortified citadels, grave circles, and bee-hive tombs (called *tholos*) built of stones (cyclopean stone for the walls). They developed a corbel arch (projecting stones capped by a single stone) and vaults.

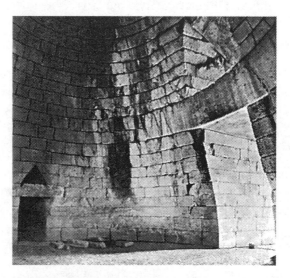

THE MYCENAEAN PERIOD: *Interior, Treasury of Arteus*, **artist unknown, 1,300–1,250 B.C. Stone block. Mycenae.**

They used stone, stucco, wood, and rubble. Their buildings appeared heavy and cumbersome.

The Mycenaeans further developed the Megaron into a domestic-unit and later adapted it into the first religious temple of the Hellenic civilizations.

4.4.2 Mycenaean Sculpture

Few Mycenaean sculpture examples survive today. What was made appeared small, portable, and carved out of ivory or fashioned from terra-cotta. Mostly religious figures were made as well as some genre (everyday) themes.

4.4.3 Mycenaean Painting

Mycenaean frescoes resembled the style of Minoan work. However, they were more stylized, stiff and crude in technique.

Sea-oriented and flora-fauna decorative patterns were used. Also introduced were themes of war and hunting. Boars, dogs, and horse-drawn chariots were popular images.

4.4.4 Mycenaean Minor Art

Mycenaean pottery was similar to Minoan in style and design. However, the patterns were less lively and colorful. The designs appeared stylized and purely decorative.

Metal-smithing was popular. In the Vaphio Alps a system of *repoussé* work (hammering out from the back) was known (perhaps originating in Crete) also, ceremonial bronze daggers with gold handles and gold *repoussé* death masks that resembled the deceased were created.

CHAPTER 5

Greek (Hellenic) Art

5.1 Origins

The downfall of the Mycenaean civilization was marked by the gradual rise of the Greek city-states. Although these "states" were separate entities, they had a common language, mythology, and heritage.

The Greeks were a migratory people, always subject to a shortage of arable land. They built settlements in southern Italy, Sicily, Asia Minor, and Egypt.

Culture and art of the Greeks centered around the concept of reason and order.

Eventually, the early tribal deities gave way to more powerful city gods. The Greeks anthropomorohized their gods, bestowing them with human shapes (as read in the Homeric epics). This related to their attitude that the human shape was the highest form of divinity. Unlike other ancient religions, the Greeks put little emphasis on the hereafter.

Four major chronological periods developed in Greek art:

1. The Geometric Period, 900–600 B.C.

2. The Archaic Period, 650–480 B.C.

3. The Classical Period, 480–323 B.C.

4. The Hellenistic Period, 323–30 B.C.

The art of the Greeks achieved a balance and sensibility. Hellenic art contained a humanistic idea and force which played an important role in later European and American art and culture.

5.2 Greek Architecture

The earliest Greek buildings (temples included) were made of wood. It is thought by some that as these rotted, their parts were replaced by stone. This resulted in the concept of "restricted originality," that is, what was done in wood was later done in stone. However, during the Archaic period, all Greek buildings were of stone.

The Greek temple plan was based on the Minoan-Mycenaean megaron. The megaron had a cella (or naos) for the cult image. At either end of the building was a porch. Greek temples had a surrounding colonnade (or peristyle). A small room behind the cella was called the sanctuary.

The Greeks developed the basic Columnar Orders in architecture. The Doric Order had an abacus (or block) and an echinus (or cushion) under the abacus. Doric was simple and had flutes on its shaft and no base. The Ionic Order had capitals with scrolls (or volutes). It was light in appearance and had a base. Finally, the Corinthian Order used Ionic volutes and rows of acanthus leaves for its capital. It also had a base. Its capital was bell shaped.

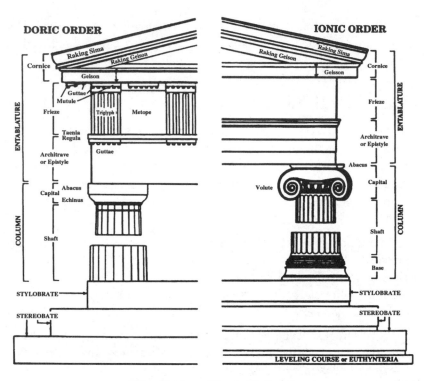

"The Doric and Ionic Orders"

Greek temples were made from cut stone, jointed without the use of mortar. They were placed on a base with three steps (stylobate-top and stereobate-bottom two). The columns were made of drums fitted into each other and held by a core of molten bronze poured down a hollow center. Flutes were then carved on these joined drums.

Greek temple roofs were fashioned from terra-cotta and supported by wood beams. Many Greek temples were painted in a variety of colors to indicate their parts. Sculptures were affixed in the two pediments (at either end of the temple) and adorned the metopes of the Doric Order and the friezes of the Ionic and Corinthian Orders.

There exist many types of buildings on the Acropolis, Athens. This site remains a testimony of the cultural achievements during the Age of Pericles.

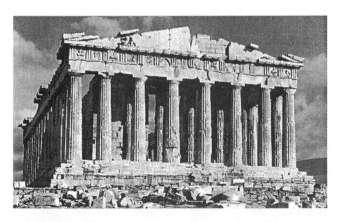

THE CLASSICAL PERIOD: *Ictinus and Callicrates*, artist unknown, 448–432 B.C. Acropolis, Athens.

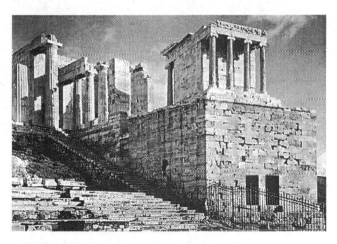

THE CLASSICAL PERIOD: *The Propylaea by Mnesicles and the Temple of Athena Nike*, artist unknown, 427–424 B.C. Acropolis, Athens.

Later, Greek architecture, between the end of the Peloponnesian War and the Roman Conquest, was found not only on the Greek mainland but in Greek colonies in Asia Minor. The tholos (a circular shrine or relic-temple house) became popular at that time. In addition, theaters and public structures such as agoras (town squares), stoas (colonnaded shrines), assembly halls, stadiums, hippodromes for chariot races, gymnasiums, naval buildings, and domestic houses were built.

5.3 Greek Sculpture

Greek sculpture showed free-standing as well as architectural reliefs. Here, gods and goddesses, heroes, etc. were represented performing tasks—mythological and war related.

The Archaic sculpture was similar to Egyptian forms, that is, stiff and frontal (Law of Frontality). Their faces were idealized, possessed an "archaic smile" and their bodies monumental and athletic in pose. The females were called Koraies (clothed maidens) and the males Kouros (nude athletes).

During the Classical period sculpture developed more of an understanding of anatomy in pose, gesture, and mien. Early Classical forms by specific sculptors such as Myron, Polycleitos, and Phidias were known. While later Classical sculptors—Scopas, Praxiteles, and Lysippos—produced more emotional and personalized figures.

The Hellenistic period was marked by a breakdown of the ideal Greek type. The gods and goddesses were said to have "descended to the earth." Dramatic realism and unidealized humans emerged. In addition, figures in groups as well as genre (everyday) themes prevailed. The influence of Greek theater affected and related to Greek sculpture at this time.

5.4 Greek Painting

Greek pottery decoration followed a definite program and stylistic development. The Geometric period style (*ca.* 900–700 B.C.) showed vases coated with a buff-colored "slip." Its designs—stylized, figurative, and geometrically patterned—were painted in black tones. The Orientalizing phase (*ca.* 700–600 B.C.) was marred by influences from the Near East, especially Persia. Colors were added, designs became bold, and mythological scenes appeared. The black-Figure Ware style (*ca.* 570–525 B.C.) reflected Archaic Greek sculpture. The figures appeared stiff and rigid. They were painted black and the background left natural terra-cotta red. The artist (many vases were signed) incised or cut the parts within the black figures. There followed the Red-Figure Ware style (*ca.* 525 B.C. onwards). Here,

the background was painted black and the figures were left in the natural color, terra-cotta red. The figures were fluid and followed the shape of the vase. Figures sometimes appeared foreshortened. Finally, in White-Figure Ware style (Fifth–Fourth Centuries B.C.), the vase was painted with a white slip. Figures were painted in a thin, delicate, supple black line.

There were many shapes for these vases. The more popular were: amphora, hydra, crater, and lekythos.

Some frescoes were done, although they were not popular.

5.5 Greek Minor Art

Greek minor art produced terra-cotta and bronze statuettes that followed sculptural styles. Coins were struck as early as 500 B.C. that showed mythological themes or national heroes.

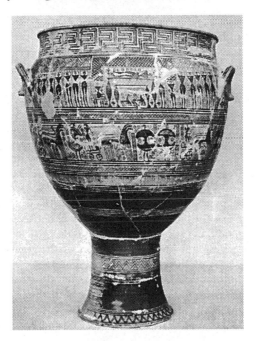

THE GEOMETRIC PERIOD: *Dipylon Vase*, **artist unknown, Eighth Century B.C. Pottery. Metropolitan Museum of Art, NY.**

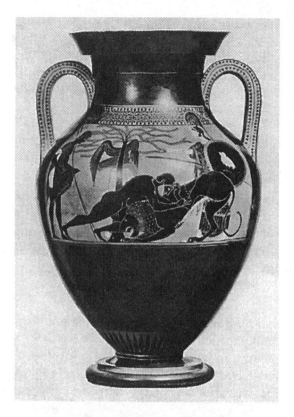

THE GEOMETRIC PERIOD: *Psiax Vase: Hercules Strangling the Nemean Lion*, artist unknown, 325 B.C. Pottery. Museo Civico, Brescia, Italy.

CHAPTER 6

Etruscan Art

6.1 Origins

The Etruscans arrived in Italy between 1,100 and 800 B.C. They were seafaring invaders from the eastern Mediterranean Sea who settled in the north-central region of Tuscany and dominated Italy from the Eighth to the Sixth Centuries B.C. Later, they were conquered by the Gauls and Romans, who arrived between 400 and 100 B.C.

In the Seventh Century B.C. the Etruscans fell under Greek influence. For this reason, Etruscan art resembles that of the Greek Archaic period. The pantheon of deities of the Etruscans mirrored that of the Greeks.

6.2 Etruscan Architecture

Practically no Etruscan architecture survives today. Their cities were destroyed by the Romans. Only a few Etruscan tombs have survived. And what is known about Etruscan architecture comes from Roman sources.

The Etruscan temple had a unique style. It was raised on a platform, approached by a single flight of stairs, made of wood with painted terra-cotta pitched roofs and had terra-cotta sculpture on its top. It had a porch of columns before a tripartite cella. The columns

had plain shafts, Doric capitals, and a base unlike the Greek Order. In general, the Etruscan temple lacked order, logic, and proportion.

The Etruscans created some rock-cut tombs of rectangular shapes that resembled Egyptian tombs. However, a more popular type was the tumulus. This was a mound of earth placed over a tomb. It had thick walls at its base and its interior had narrow chambers with sarcophagi and wall frescoes. The tumulus was located outside the city proper. It was an abode for Etruscan clans to dwell in the afterlife.

The Etruscans built high stone arch gateways to fortify their cities. They used cyclopean stones held by bonded and squared masonry. They also created a system of drain architecture with voussoir barrel vaults, that is, wedge-shaped bricks or blocks of stone used in a series to form an arch.

6.3 Etruscan Sculpture

Etruscan sculpture of the Seventh to the Sixth Centuries B.C. echoed Archaic Greek types. The figures were stiff and followed the Law of Frontality. Their hair fell in elaborate locks and some bore the Greek "Archaic-smile." Their eyes were almond-shaped and bulged. They revealed an over-all heavy proportion and showed a careless execution of details.

Later, Etruscan sculpture became more realistic than Greek prototypes.

Etruscan sculpture was based in temples and tombs. The sizes varied from small bronze statuettes to life-size hollow bronze and painted terra-cotta images.

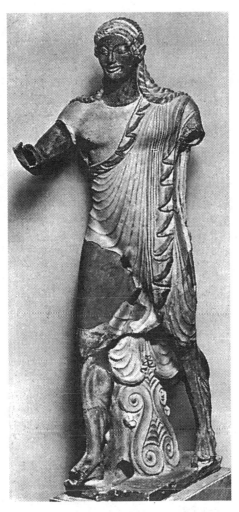

ESTRUSCAN PERIOD: *Apollo*, artist unknown, 510 B.C. Stone. Museo Nazionale di Villa Giulia, Rome.

Etruscans made "fantastic" beast-like bronzes or chimera that suggested a Persian influence.

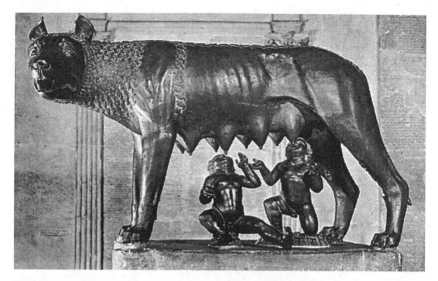

ETRUSCAN PERIOD: *She-Wolf*, **artist unknown, 500 B.C. Bronze. Capitoline Museum, Rome.**

6.4 Etruscan Painting

Etruscan frescoes (dry and buon) were Egyptian-like. Their figures followed the Law of Conceptuality. Fresco painting was found primarily in tombs covering expansive areas of the walls. The style was bold and decorative. The themes, mostly genre, were created with breadth and fluidity. Most popular were hunt, banquet, and military scenes. For the most part, the frescoes showed the Etruscans having a pleasurable life in the hereafter.

6.5 Etruscan Minor Art

A variety of minor art objects were made during the Etruscan period. Popular were Greek-style pottery that was imported from Athens and Corinth during the Greek Archaic and Classical periods and homemade black and red figure wares. A native style, called Bucchero pottery arose having both thin and thick walls with stamped or modeled reliefs on the surfaces.

Human-headed terra cotta cinerary urns, bronze mirrors, shields, ornate jewelry, and toilet boxes were also made.

CHAPTER 7

Roman Art

7.1 Roman Art

Rome was under Etruscan rule through the Sixth Century B.C. Etruscan domination ended in 509 B.C. when the Gauls swept into Italy and with the expulsion of the Etruscan kings by the Romans. By 237 B.C., Italy was under Roman rule. There followed the three Punic wars with Carthage; and when these ended in 146 B.C., the Romans added many countries to their expanding empire.

Because of over-expansion, political discontent, and barbarian invasions, the Roman Empire began to fall. However, before its demise, Emperor Constantine moved its capitol to Byzantium; and by 365 B.C. the Roman Empire was split into East and West. Christianity overcame Roman paganism, and its rulers could not hold the old Empire together. Finally, in 476 A.D., the Roman Empire in the West came to an end when the Germanic general, Odoacer, was made the first King of Italy.

Roman art emerged in the Third and Second Centuries B.C. Roman art synthesized Greek-Hellenistic, Classical Greek, and Etruscan styles. Roman art was political. It symbolized the power of the Emperor. In this sense, Roman art was uniform. Whether in architecture, sculpture, painting, or minor art, Roman art reflected the political unity of its people.

Roman art continued the Greek artistic tradition; Roman artisans did not add to the Greek style, rather they copied and even destroyed Greek originals. Why Roman artists destroyed Greek originals remains a psychological question today. Perhaps, the Romans wanted to say that they did a certain theme "first." Many scholars say that Roman art vulgarized Greek art. Except for architecture, Roman art showed little creativity or originality. The Romans were not only great eclectics, but had the ingenious power to absorb and assimilate Greek styles. Roman art is divided into two periods:

1. The Republican period, *ca.* 509–27 B.C. The beginnings to the rise of Roman emperor Augustus of Prima Porta);

2. 27 B.C.–476 A.D. (Augustus' rule to the fall of the Roman Empire by Odoacer)

7.2 Roman Architecture

Roman architecture did not manifest itself until 27 B.C. It was during this time that the Romans exhibited a genius for construction, city planning, and engineering. They conceived buildings as homogenous masses rather than individual parts as did the Greeks. They exploited the structural possibilities of concrete and burnt brick. Roman architects emphasized interiors. Roman building façades were likened to stage decoration. Consequently, one could not relate the exterior to the interior in Roman architecture. Light became an important factor. Through diffused effects, light illuminated hidden recesses of Roman buildings.

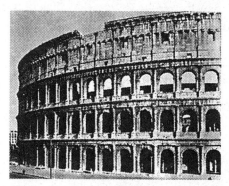

ROMAN PERIOD: *The Colosseum*, artist unknown, 72–80 A.D. Stone. Rome.

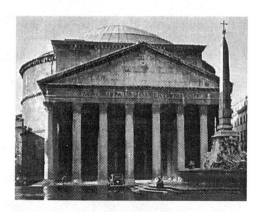

ROMAN PERIOD: *The Pantheon,* **artist unknown, 118–25 A.D. Traver- tine limestone. Rome.**

Among other architectural devices, the Romans exploited: the arch motif; the barrel and groin (two barrel vaults crossing at right angles) vault system; opera or stone-work methods of decoration; and concrete or "synthetic stone" used for walls, vaults, and domes. Travertine limestone and tufa were popular for their building founda- tions and exterior facings. Richly veined marble and multi-colored stone mosaics (tesserae) were used in interiors.

The barrel vault became in integral part of Roman architectural schemata. With the introduction of the barrel vault, large areas were easily covered, for the earlier post-and-lintel roof construction had structural limitations. The post–and–lintel construction could only enclose an area as long as the horizontal lintel; however, with the barrel vault, a "springing" effect was achieved (walls could be built further apart), and therefore more space could be covered via this "spring."

In addition to the barrel vault, the Romans conceived the groin vault. In the groin vault system two barrel vaults cross at right angles (or simply intersect). In addition, a method of coffering was used. Coffers were sunk panels found in vaults, domes, and ceilings.

Roman architects used Greek Orders. They even added another Order, the Corinthian Composite. The Corinthian Composite was a further elaboration of the regular Greek Corinthian Order.

37

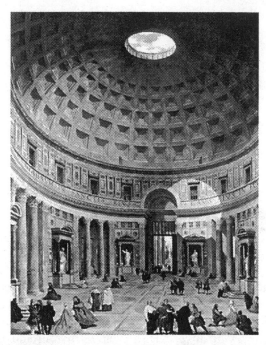

The Interior of the Pantheon, G.P. Pannini. Painting. 1,750 A.D.

The Romans employed stone in their buildings. They also used concrete faced with brick. As a result of the use of concrete faced with brick, the so-called opera methods were adopted. The opera methods were as follows:

1. *Opus incertum*—the facing of concrete walls with irregular fragments.

2. *Opus recticulatum*—the facing of concrete walls with small square blocks. The small square blocks stood on their corners in diagonal lines.

3. *Opus latericium*—brick facing in courses.

4. *Opus mixtum*—uniting opus incertum and opus latericium.

There were multiple Roman architectural types: temples (rectangular and round); baths or thermae; basilicas (indoor markets or meeting halls); amphitheaters for outdoor gladitorial combats, etc.; fo-

rums, similar to the Greek agoras for religion, law, and politics; circuses for chariot and horse races; arches to commemorate emperors' or generals' victorious campaigns; gateways that were part of a protective wall or for forums and market places and archways constructed at main street intersections; columns or pillars to record victories of emperors or generals; palaces, civic and sacred, placed within fortified walls; houses—private, villa–type or insula (many-storied); aqueducts which carried water to large cities; bridges made of wood and later stone; paved highways and streets that connected and held together the far-reaching Roman Empire; and fountains built as water shrines for private and/or public courts and gardens.

7.3 Roman Sculpture

The Romans developed an interest in the realistic portrayal of the individual. Political, military, and civic leaders, as well as gods and goddesses, were created in marble and bronze. The gods and goddesses appeared idealized and synthesized Greek and Etruscan models. The Romans gave their figures a monumental dignity and constrained sobriety.

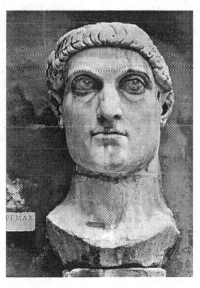

ROMAN PERIOD: *Constantine the Great*, artist unknown, Fourth Century A.D. Marble. Capitoline Museume, Rome.

Different types of sculpture were created:

1. full–length figures—emperors, generals, political images
2. the equestrian type—an over life-size hero on horseback
3. bust portraits and heads—unpainted, realistic in portrayal
4. bas-reliefs adorning altars, columns and arches and
5. sarcophagi showing reclining full–length figures on lids with reliefs around the flanks

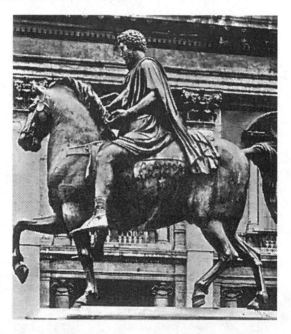

ROMAN EMPIRE: *Equestrian Statue of Marcus Aurelius*, **artist unknown, 161–80 A.D. Bronze. Piazza del Campidoglio, Rome.**

7.4 Roman Painting

Roman paintings were executed by professional artisans. The Roman painter was inspired by Greek masterpieces. Different types of paintings were made. Fresco painting decorated public buildings and houses. Panel paintings were found in private houses. Mosaic work was also categorized under paintings and used to decorate building and house interiors.

Other types of paintings were on marble panels and glass: Encaustic style (paint mixed with wax) painted on panels inserted in Egyptian mummy cases.

There arose many "styles" of Roman fresco paintings were:

1. The incrustation style – (*ca*. 200–80 B.C.) showed the imitation of colored panels.

2. The architectural style – (*ca*. 80–10 B.C.) involved painting of architectural motifs. The style was also cha erized by chiaroscuro effects and bright colors. This styl er saw figures placed within the architecture. Some of t igures appeared solid black.

3. The intricate style – (*ca*. 50–79 A.D.) used bri colors against dark backgrounds. Whole interiors were cc d with paintings. This, in turn, gave a feeling of space a hysical depth. The intricate style was partly based on ori l influences.

Practices of the Roman painter were as follows:

1. Used a three-dimensional illusionism.

2. Represented sequential receding planes by a d e called chiaroscuro (chiaroscuro (light-and-dark contrast

3. Modeled figures in heave and dark outlines.

4. Used a varied and graduated palette.

5. Used opaque colors.

6. Adopted his style from the Greeks.

Early Christian and Byzantine Art

8.1 Early Christian Art

8.1.1 Origins

The decline of the Roman Empire was accompanied by a decline in Roman religious beliefs. The emergence of Christianity as a religious movement filled this vacuum. People throughout the Empire now converted to Christianity.

Within the Early Christian period there were many significant dates of historical and religious importance:

312(313)—The Edict of Milan which granted equal rights for all religions.

324—Emperor Constantine declared himself a Christian.

330—Constantine removed the capital from Rome to Byzantium.

395—The Roman Empire was divided into East and West Empires.

431—The Council of Ephesus said that artists should take their directions from the Church.

The dates attributed to Early Christian art fall approximately from 33 A.D. (the time of Christ's death) to about 500 A.D. (the total "recognition" of Christianity).

During the "Period of Persecution," most art work was conceived as ceiling and wall paintings in catacombs (below ground funeral chapels and burial vaults). There followed "After Recognition" whereby art became a visible manifestation.

8.1.2 Early Christian Architecture

Early Christian architecture began in the third decade of the Fourth Century A.D. This marked the beginnings of "After Persecution" when Christians could practice their beliefs in sacred buildings above ground. These structures were called basilicas, after the Roman term meaning "meeting place". In early Christian times, basilica, meant kingly or a kingly meeting place.

The architecture of the Early Christian period was primarily fashioned from timber, marble, brick, and "looted" columns taken from Roman buildings. There developed two types of church plans:

1. The Latin Cross Plan

2. The Central or Circular Plan

The Latin Cross Plan (or Long Plan) was cruciform in shape— oriented usually West (the entrance) to East (the alter facing Mount Calvary). It was approached by a single flight of stairs that led to an open courtyard or atrium (where, in the center, a baptismal font was placed for Conversion). This led to a closed-in portico called a narthex. The narthex led to the interior of the basilica. Within the basilica was a central aisle, called a nave, and to either side of the nave were aisles (single or double). Above, there were a series of windows, called the clear–story and below them was a ground arcade of columns supporting arches or an entablature (cornice, frieze, and architrave adopted from Antiquity). Cutting across the nave and aisles at right angles was the *bema* or transept (the short–arm of the Latin Cross). To approach the transept, one would pass under an arch called "The Arch of Triumph." Beyond the transept was a projecting niche or apse that contained the altar. The ceilings were flat and

made of timber (later, they showed square indentations or coffers adopted from Antiquity). Trussed beams supported a pitched room above the central aisle (or nave) and the side aisles. Sometimes, bell towers and private chapels were attached to the body of the church.

Later, the atrium became a cloister area and was attached to the side flank of the church.

The Latin Cross Plan recalled Egyptian New Kingdom temples and echoed the shape of Roman basilicas.

The Central or Circular Plan church was less popular. Churches of this type were also oriented West to East. The plan revealed two concentric circular aisles and in the center was the nave. The center of the nave contained the alter and "The Arch of Triumph."

It is noteworthy that the Central Plan followed the arrangement of the Roman Pantheon which had a dome-on-drum construction.

Both the Latin Cross and Central Plan churches exhibited plain, unadorned exteriors and decorative, elaborate marble, and mosaic interiors.

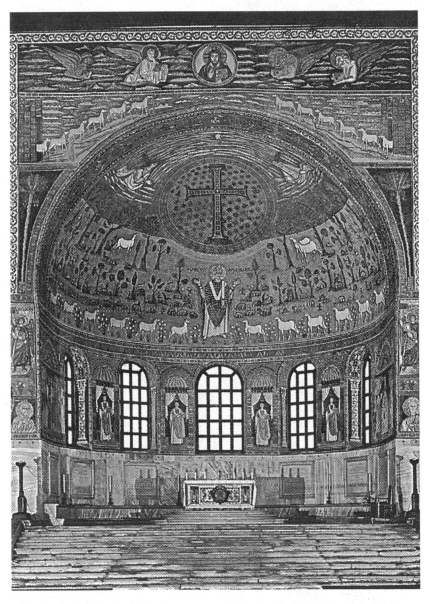

EARLY CHRISTIAN PERIOD: *Saint Apollinare in Classe*, artist unknown, 533–49 A.D. Ravenna.

8.1.3 Early Christian Sculpture

There were not too many Early Christian images in-the-round. Those found—primarily The Good Shepherd theme—were fashioned from marble and ivory and mirrored Roman styles. Of course, many of the earliest Christian artisans were converted pagans.

On the other hand, Early Christian marble sarcophagi relief sculptures were quite popular and significant. The method of carving was likened to pagan sculpture. However, later themes became infused with a transcendental spirituality. Images were carved to a uniform depth to symbolize that "all was equal unto the Eye of Christ." The total effect was polychromatic although no color was used.

The sarcophagi were covered with continuous narrative scenes from the *Old* and/or *New Testaments* which ran together as in a frieze. The style was illusionistic. Sometimes the figures were repeated for didactic reasons.

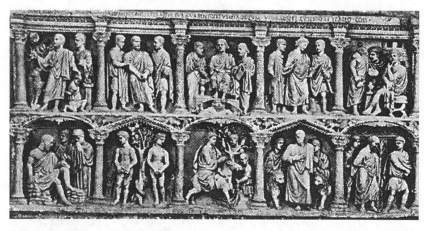

EARLY CHRISTIAN PERIOD: *Sarcophagus of Junius Bassus*, Junius Bassus, 369 A.D. Marble. Vatican Grottoes, Rome.

Also, Early Christian diptych (two-hinged panels) sculpture had an aesthetic appeal. Diptych sculpture appeared spiritually possessed as the figures looked inorganic and physically elongated in their characteristic frontal positions.

8.1.4 Early Christian Painting

The earliest Christian painting was executed on the walls and ceilings of underground catacombs. Catacombs were located in and around Rome. These paintings date from the First to the Fourth Centuries A.D. Their subject matter was primarily Christian. Scenes from "The Life of Christ" were common. Also, depictions' of Christ, or the Virgin in prayer (orante), were notable. Other popular themes show Christ as Good Shepherd or merely with The Apostles.

The purpose of the paintings was to venerate Christ. The style was direct and simple. Large, frontal images with heavy, dark outlines were used. Sometimes, there was a hint of modeling in the heads, arms, and legs. Bodies were garbed in Classic attire (togas) or biblical robes. There was no indication of a setting or landscape. Colors were earthen with touches of off-whites, golds, and blues. Floral or foliate patterns usually were scenes of the Vintage.

If *Old Testament* themes occurred, they related to Christian concepts of Salvation and Redemption such as the many Jonah-and-the-Whale references.

Early Christian mosaics followed the technique and manner of the Romans. The Early Christians created miles of mosaics to adorn their basilicas and shrines. The subject matter was mostly Christian, not pagan, although again some *Old Testament* themes referred to the idea of Christian Salvation and Redemption or prediction of a Messiah.

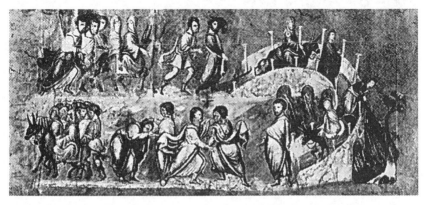

EARLY CHRISTIAN PERIOD: *Jacob Wrestling with the Angel,* **artist unknown, Sixth Century A.D. Vellum. National Library, Vienna.**

47

The mosaic artisan chose to use gold (or spiritual) backgrounds for his images rather than naturalistic blues.

To achieve a spiritual effect, the figures were more elongated than pagan types and appeared inorganic. As in catacomb painting, artists used a dark, heavy outline around forms and placed them in a frontal position. The faces were stylized, eyes made large and staring into another world. Images often seemed often to float and hover weightlessly across the wall surfaces.

The richly-colored mosaics, now made from glass rather than stone, gave an emotional atmosphere of polychromy to the dark basilica interiors.

Another area of Early Christian painting could be found in manuscript art. On vellum (calf-skin) or parchment (lamb-skin) artists painted themes relating to Christian liturgy. Early examples separate the pictures from the text (usually in Latin). Later works infuse the text with the pictorial representation. In either case, these manuscripts give an illusionistic suggestion of space and depth through dark and light contrasts and cast shadows. Their colors were opaque, dull, and sometimes dark.

The technique usually involved the use of a thinned tempera (pigment and egg yolk mixed) or merely ink and colored washes.

8.2 Byzantine Art

8.2.1 Origins

Byzantine art dates from 330 A.D., when Constantine dedicated Constantinople as his capitol, to 1453, when the Turks captured Constantinople.

Byzantine art dealt with the East Christian world of Greek-speaking peoples. Scholars say that Byzantine art was one of pronounced formulas. It was a monumental art filled with power, dignity, and pictorialism. Ultimately, the Byzantine style united oriental and Greek ideas. For the most part, Byzantine art was an "applied" art, that is, its technique showed a delicacy of handling and a construction by

line, color, and rhythm. It was also one of distortion for a spiritual effect. In this sense, it became visionary and otherworldly. Byzantine art was unique in that over eleven centuries it maintained a pictorial consistency and stylistic homogeneity.

8.2.2 Byzantine Architecture

Byzantine architecture was theological and intellectual. It combined Greek philosophy with Christian belief. In style, it achieved a specific formula: an organization of subordinate masses receiving the thrust that originated in the apex of the cupola (a small dome or spherical roof over a circular area). All elements of a Byzantine building radiated from the center dome. Byzantine architecture was characterized by its weighty mass, spanning arches, barrel and groined vaults, and squat domes. Favorite materials used were brick, rubble, and local stone.

Exteriors of Byzantine buildings were heavy and thick in appearance. Line was always horizontal and profile irregular. Byzantine architects repeated motifs such as domes, projecting apses, and exedras (recessed alcoves within the church).

Internally, Byzantine architecture was pictorial in its jewel-like brilliance. Colorful mosaics and richly veined marbles were used. A technique for undercutting marble was exploited using a drill effect.

Probably the most important contribution made to architecture by Byzantine builders was the system of placing a dome-on-pendentive (triangular curved overhanging surfaces upon which a circular dome was supported over a square or polygonal compartment). The method was simply placing a circular dome on a smaller square base. The pendentives carried the weight of the dome. Sometimes a squinch (arches to uphold the dome on the pendentives) gave greater support to the load.

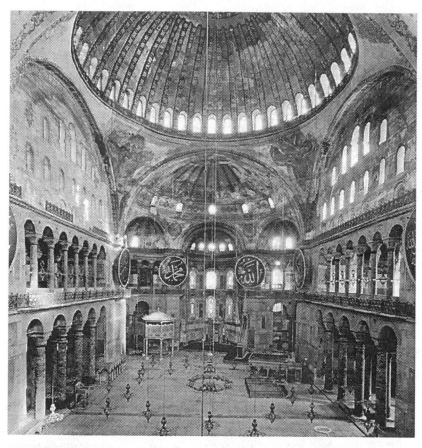

BYZANTINE PERIOD: *Anthemius of Tralles and Isidorus of Miletus,* Hagia Sophia, 532–37 A.D. Stone. Istanbul.

Three basic types of church construction existed:

1. The Latin Cross Plan basilica with timber roofs
2. The Central Plan (either circular or octagonal
3. The Mixed Plan which incorporated both basilican and central plans.

Within the Mixed Plan were:

 a. the domed basilica

 b. the Greek Cross Plan which had four "arms" of equal length with domes over or between these arms.

Upper galleries, reserved for women only, were characteristic of Byzantine architecture. These were placed over the aisles or ambulatory below. Greek orthodox religion separates men from the women.

8.2.3 Byzantine Sculpture

Byzantine sculpture was considered the least of their creative arts. What was done appeared on a small, portable scale. Some devotional figures were carved in-the-round or free-standing, while others were in bas-relief. The choice of material was usually ivory, although some marble and limestone for sarcophagi were used. The figures appeared elongated and inorganic. Drapery was reduced to a system of striated pleats or flat-folds. Heads were schematic and mask-like. Carving was delicate. The Byzantine artisan gave a feeling of decorative, applied art to his work. As in Early Christian art, religious symbols were employed profusely in a patternized way. Most notable was the "alpha-omega" sign and the peacock sign.

8.2.4 Byzantine Painting

Byzantine painting consisted of religious mosaics, frescoes, icons on panels, and manuscripts.

Byzantine mosaics possessed a Near Eastern brilliance. Thousands of polygonal colored-glass pieces were set into church walls and apses. The figures were flat and schematized. Their bodies seemed to float as they appeared frontal and inorganic. Their faces were mask-like, spiritually transfixed as they stared off into another state of existence. The total effect was one of otherworldliness.

Byzantine frescoes replaced mosaic art at the end of the Byzantine Empire. What was said about mosaics also applied to fresco work. The figures were tall and elongated. They seemed to levitate. There was no indication of perspective and space was entirely spiritual, if not visionary.

Byzantine icon or panel paintings were most noteworthy. These developed during the time of the so-called Iconoclastic Controversy (717–843 A.D.) which was an attempt to purify the Church of super-

stitions and images of any kind. These panels of encaustic on wood, usually depicting the Madonna or Madonna enthroned holding the child, related to Graeco-Roman portrait panels found in Fayum, Egypt from the First Century A.D. Their style was highly schematic and depersonalized. The figures show large eyes that stare off into a spiritual realm. Arched eyebrows blend into the bridge of the nose, while the lips are small. There is a slight suggestion of modeling around the cheek and chin areas. An over-all severity and monumentality prevail. Backgrounds were made from burnished gold leafing which intensified their spirituality.

Lastly, Byzantine manuscripts showed biblical narrative and symbolic figures schematically flat and otherworldly in appearance.

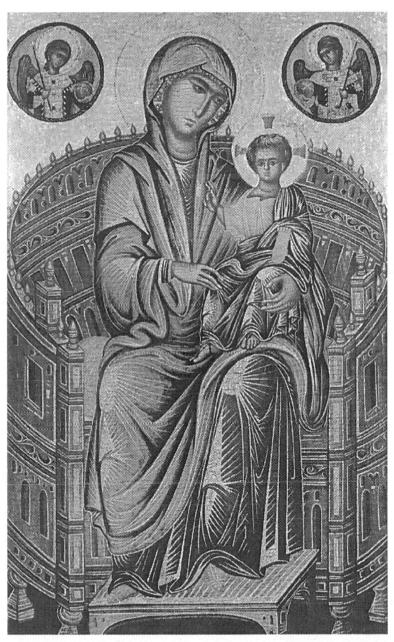

BYZANTINE PERIOD: *Madonna Enthroned*, artist unknown, Thirteenth Century. Tempera on panel. National Gallery of Art, Washington, D.C.

CHAPTER 9

Art of the Middle Ages

9.1 Migrational Art

Migrational art took place between 375 to 750 A.D. when assaults on Europe began. At first, the Northmen sent raiding parties and then gradually established bases on the Continent. These later became permanent settlements. The Northmen came from Ireland and the Scandinavian peninsula. They were a bold, seafaring people related to Germanic tribes in culture and custom. They brought with them not only their own traditions, but also the influence of the East.

Migrational art developed two styles:

1. The animal style

2. The decorative style

The most significant aspect of Migrational art was its use of animal figures—real and imaginary. The decorative style developed interwoven "strap" patterns of great detail and elaborate complexity that echoed an eastern origin.

Migrational art brought into Europe by the invaders had items that could be work or carried. Buckles, and jewelry were carefully worked in metal. Many were inset with precious and semi-precious stones. The technique of *cloissoné* was used. *Cloissoné* was the arrangement of wire bands (or cloisons) into a design. The area be-

tween the cloisons was covered with enamel to provide a rich, jewel-like surface. This technique was used by the Celts and Saxons from the Third Century A.D. onward.

MIGRATIONAL PERIOD: *Purse Cover from the Sutton Hoo-Ship Burial*, artist unknown, 655 A.D. Gold and enamels. British Museum, London.

In addition to metalwork, the Migrational artisans carved intricate, complex wooden ship figure-heads with monster beast imagery as well as objects for Anglo-Saxon ship burials such as purses, helmets, harps, and utilitarian objects all to accompany the deceased to the hereafter.

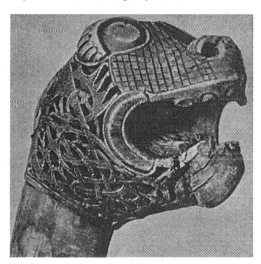

MIGRATIONAL PERIOD: *Animal Head*, artist unknown, 825 A.D. Wood. University Museum of Antiquities, Oslo.

Interesting to note is that the Migrational style of metalwork influenced later Irish stone cross designs.

9.2 Hiberno-Saxon Manuscripts

When St. Patrick arrived in Ireland in the Fifth Century A.D., he found a rural land of Celtish people who had lived through the era of the Roman Empire without being affected by it. Within a decade after his arrival, Ireland adopted Christianity with such fervor that soon it sent its own churchmen to England and the Continent. They, in turn, competed with the Church of Rome.

In Irish monasteries, artisan monks developed an infinitely complex, detailed style of manuscript art that emphasized abstract design. Almost mirroring Islamic art, Irish (Hiberno) and English (Saxon) monks used similar geometric strap designs and patterns that recalled Migrational art. Animals and sometimes human heads were incorporated into the pattern weave. Foliage was not used. In some manuscripts illustrations "mirrored" each other on left and right pages. Famous books—Durrow, Lindisfarne, and Kells—were produced. Their complex Carpet, Cross and Author pages showed an ironical unity of style between the uncivilized Migrational art and the deeply ecclestiastical mode.

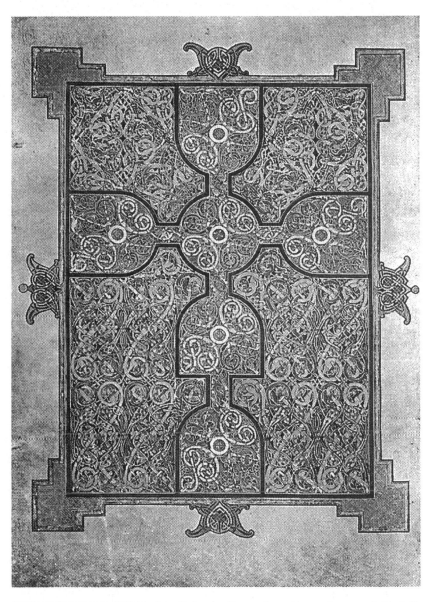

MIGRATIONAL PERIOD: *Lindisfarne Gospels*, artist unknown, 700 A.D.
Manuscript. British Museum, London.

There was no architecture of importance during the Migrational epoch. And as already cited, monumental stone Irish crosses echoed the Migrational manner as well as Hiberno-Saxon manuscript style.

9.3 Carolingian Art

9.3.1 Origins

From the Fifth to the Seventh Centuries A.D. France and western Germany were ruled by the Merovingian kings. Merovingian art was like its rulers—coarse, crude, and unoriginal. It was a bad mating of Early Christian and Migrational styles. Toward the end of the Seventh Century A.D., Pepin the First took control of the government and what followed was the Carolingian period (750–900 A.D.).

The cultural reforms that came during the reign of Charlemagne (742–814 A.D.) were based on Ancient Roman literature and art. Emperor Charlemagne had monks copy the works of classic Latin authors to insure a continuity of thought from Roman times to his reign. He strove to implant the Roman cultural traditions within the framework of his semi-barbaric empire. This revival or "renaissance" fused the Mediterranean world with the Celtic-Germanic tradition.

9.3.2 Carolingian Architecture

Charlemagne visited Italy many times, carefully observing the architecture of Constantine's Rome and Justinian's Ravenna. From these observations, he had built Latin Cross basilicas; his own tomb house at Aix-la-Chapelle, Aachen, Germany; and huge monasteries such as St. Gall, Switzerland. Known architects—Odo of Metz and Eginhardt—conceived many of these structures. They appeared massive and weighty. Their exteriors were drab, but their interiors (like those of the Romans) were polychromatic through the use of rich marbles and mosaic work.

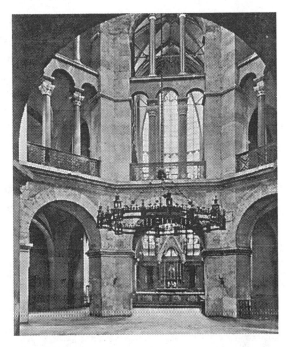

CAROLINGIAN PERIOD: *Interior, Palace Chapel of Charlemange*, Odo of Metz, 792–805 A.D. Aachen.

Also notable was the introduction of a western entrance to churches, called the westwork. In addition, a square schematicism (or proportional division within the basilica) was introduced.

9.3.3 Carolingian Sculpture

Sculpture during the Carolingian period was of limited variety. Few noteworthy examples emerged.

9.3.4 Carolingian Painting and Minor Art

In painting there are no surviving Carolingian frescoes. However, manuscript illuminations have survived. There developed different "types":

1. The Palace School—which showed a Classic feeling since Charlemagne fashioned his Empire after the Romans.

2. The Reims School—which was based on the Palace style but its mode revealed Classic-like drapery in nervously rendered patterns of dynamic, linear folds such as The Utrecht Psalter—which was a style developed by Carolingian artisans inspired by Hellenistic art and the Reims School. All these manners ultimately combined Hiberno-Saxon designs with a pictorial illusionism from Mediterranean sources.

In addition, luxuriously fashioned manuscript book covers were made. They exhibited bronze Crucifixions surrounded by richly encrusted gold and multi-colored jewels. This style echoed metalwork from the Migrational period with a restraint and symbolism derived from Early Christian art.

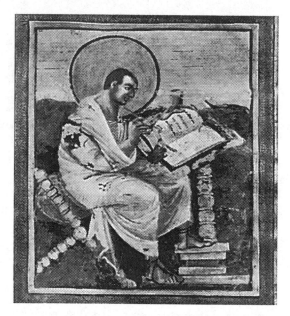

CAROLINGIAN PERIOD: *St. Matthew, from the Gospel Book of Charlemange*, artist unknown, 800 A.D. Manuscript. Kunsthistorisches Museum, Vienna.

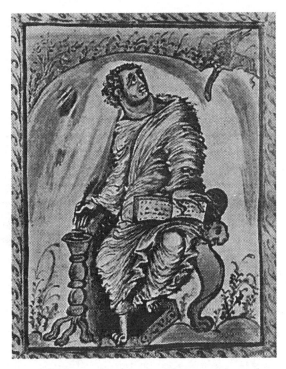

CAROLINGIAN PERIOD: *St. Mark, From the Gospel Book of Archbishop Ebbo of Reims*, artist unknown, 816–35 A.D. Manuscript illumination. Municipal Library, Epernay, France.

9.4 Ottonian Art

9.4.1 Origins

After a period of disorder following the decline of the Carolingian dynasty, the Saxon king, Otto I, came to the throne of Germany. He rebuilt the German Empire—re-establishing the German emperors as Holy Roman Emperors, and brought about what has been called the "Ottonian Renaissance" (900–1056). The culture of the East, following the Islamic invasions, had made itself felt in Europe. This marked the beginning of the intellectual revival that would come during the "High" Middle Ages. Subsequent Saxon kings re-established the connection between Byzantium and the West. This, combined with the Classic revival that had been stimulated by Charlemagne, served to

bring about artistic and cultural changes that signified the approach of a new era.

9.4.2 Ottonian Architecture

The architectural designs that had developed during the Carolingian period were refined, extended, and amplified to meet the needs of a church that had the encouragement and support of the German (Saxon) kings. Men like Bernward, Bishop of Hildesheim (a tutor to Otto III) were representative of the combination churchman-craftsman, trained in both the spiritual and aesthetic way of life. Latin Cross basilican plans dominated. The westwork was elaborated. The square schematism and geometric formality was furthered. Also, basilicas showed more towers and turrets as they grew in size and scale. Still, exteriors were unadorned and interiors remained more elaborate with a decorative use of marble. Some basilicas had twin apses.

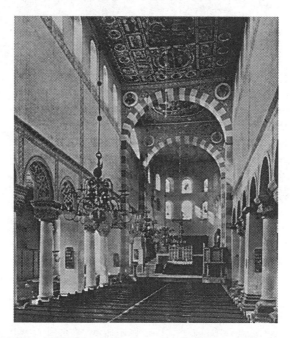

THE OTTONIAN PERIOD: *Interior, St. Michael's Hildesheim*, **artist unknown, 1001–33. Hildesheim.**

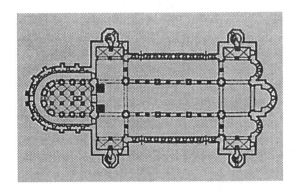

Reconstructed Plan of St. Michael's.

9.4.3 Ottonian Sculpture

The Ottonian era re-introduced large free-standing sculpture, especially noted in the expressionistic, passion-oriented, polychromatic wood (oak) Crucifixes. Relief work was also larger in scale than in Carolingian times. Its linear manner, usually executed in bronze, echoed manuscript illumination.

THE OTTONIAN PERIOD: *The Gero Crucifix*, artist unknown, 975–1,000 A.D. Wood. Cathedral of Cologne.

9.4.4 Ottonian Painting and Minor Art

Some frescoes survived whose style mirrored manuscript art.

Manuscript painting still was most popular. It was more formal and disciplined than Carolingian types. Now, religious and/or courtly figures dominated the narrative themes. A mystical expressionism developed and color took on symbolic proportions.

9.5 The Romanesque Period

9.5.1 Origins

The Romanesque period encompassed the Eleventh and Twelfth Centuries. The period of invasions was past, and the European community began to re-establish itself.

Feudalism provided some military and economic security. Regional rulers wielded more real power than kings. Capitalism, commerce, and banking changed the structure of society in Europe.

The one strong unifying influence during the Romanesque period was the Church, whose authoritarian rule extended beyond the spiritual into every aspect of community life. Although the Romanesque style might have been drawn from the Classic past, it took its inspiration from the church-dominated culture of the present. In 1095, the First Crusade with a huge international army gathered in response to a call from the Pope. This marked the high point of the Church's power. But the reform movement that had already begun in the monasteries of Cluny soon brought a searching public eye on the activities and attitudes of the church hierarchy. During the Romanesque period, the church remained the predominant influence in western Europe.

9.5.2 Romanesque Architecture

There is a basic incongruity within Romanesque architecture. The incongruous fact is that although Romanesque architecture is generally homogeneous in appearance, there are many heterogeneous buildings within the style. Romanesque churches varied from country to country and region to region. The name "Romanesque" means "like the Romans" or Roman-like, with many superficial architectural elements

reflecting Roman architecture. (For example, the use of heavy proportions, the barrel vault, rounded arch, drab exteriors and the use of sculpture with architecture.) Buildings have few windows and the rounded arch is emphasized. However, there are basic characteristics that are indigenous to Romanesque architecture. They are as follows:

The Romanesque was the first period to make use of the tower as an integral part of the church design. Many Romanesque churches were built not only with the single tower (called the "lantern tower") over the crossing of transept and apse, but with other towers as well. In many, there was a tower in isolation, called a bell tower (or campanile) that was separated from the main church itself.

Romanesque churches were built on a variety of floor plans. The "Latin Cross" plan was most used, with such variations as addition of the western transept in the German Romanesque churches (this was accompanied by an elaborate westwork facade). Some churches were built on the "Greek Cross" plan (in the Byzantine style) with domes placed over the crossing. In Italy, the basilica style was revived.

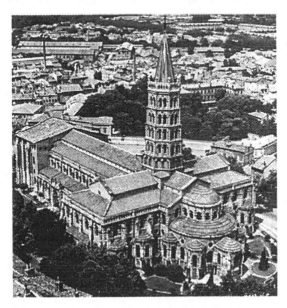

THE ROMANESQUE PERIOD: *St.-Sernin*, **artist unknown, 1080–1120. Toulouse.**

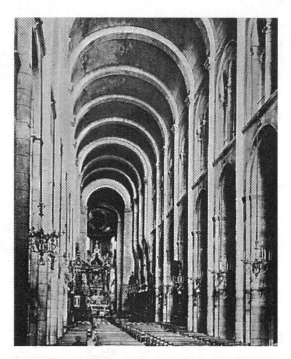

Nave and Choir, inside St.-Sernin.

The structure of the churches was as varied as the basic plan. The standard romanesque opening was the round arch. Masonry vaults were used, and the most popular were the barrel and the groin vaults. (The groin vault is found when two barrel vaults cross at right angles.) Some wood was used for beams and ceilings; but the masonry vaults allowed ceilings to be placed higher, and the use of stone rather than wood lessened the danger of fire. However, in order to support the masonry vaults (with the resulting outward pressure), thicker walls were required.

Higher ceilings led to the development of three-story buildings. In some, a gallery was constructed between the ground floor (the nave) and the clerestory level. The second level came to be known as the triforium or upper gallery in some churches this level was merely a "blind arcade" ("blind" meaning that it was filled in with masonry).

Increased interest in sacred relics and the increasing number of pilgrims that came to visit these churches led to the expansion of the aisle around the transept and the apse. This aisle, called the ambulatory, often extended into the crypt below the choir area. As a result of increased interest, the apse was enlarged, and adjacent chapels were built around it so that viewers would not disturb the service.

The Romanesque style of architecture has been noted by some historians for its "eccentricity" and its lack of consistency. Buildings were not always built absolutely "square," and irregularities were frequent and noticeable. Often it seemed the intention and not lack of knowledge of the builder to create unevenness rather than perfection. The Romanesque was a time of architectural experimentation, and many designs would be perfected later during the Gothic era.

9.5.3 Romanesque Sculpture

The Romanesque period revived monumental sculpture that had died out after the fall of Rome.

Romanesque sculpture was used in conjunction with architecture. This could be noted primarily in the portals (archivolts, tympanum, lintels, trumeaux, jambs, and splays).

Characteristic of Romanesque sculpture were elongated bodies. They appeared unreal and inorganic. They were spiritual and flat. The sculptors almost always used the frontal position for them.

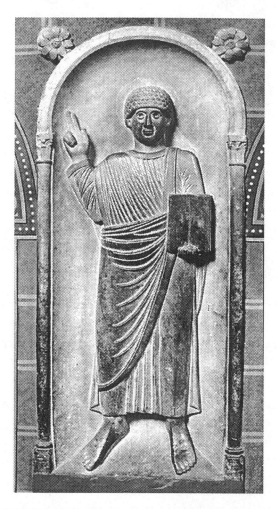

THE ROMANESQUE PERIOD: *Apostle*, **artist unknown, 1090. Stone. Toulouse.**

Another trait of Romanesque sculpture is that the drapery is planted into long, narrow folds. Also, many of the figures possess an "archaic smile." The Romanesque sculptor usually painted over his forms thus bestowing them with a rich, polychromatic feeling.

Finally, Romanesque sculpture is religiously didactic. By didactic, one means that the sculpture pictorially interprets scenes from the

Bible. For example, in the tymptanums, the Last Judgment is usually depicted to warn the viewer that if he is not good in his mortal life, he shall suffer in Hell in the hereafter. In other words, Christ will judge him. The tympanum is made up of carved bas-relief. It is a semi-circular (or lunette) shaped plaque placed between the door lintel and doorway arch. The tympanum is covered with relief zones or friezes around a central figure of Christ, who usually appears as Judge over all mankind.

The trumeaux (columns below the tumpanums) show grotesque demons and satanic forms devouring the evil sinner. Again, another pictorial warning to the observer to be good—or else. The capitals of the columns are different than in Classic times, for they now reveal scenes from the Bible or graphically portrayed profane matter.

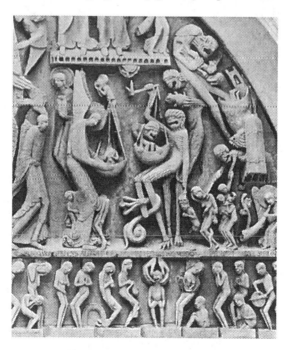

THE ROMANESQUE PERIOD: *Last Judgment*, **artist unknown, 1130–35. Autun Cathedral.**

69

9.5.4 Romanesque Painting

Romanesque painting fell into three areas:

1. Fresco

2. Manuscript

3. Panel

Dry frescoes were made with pigments mixed with water or glue-based substances. Colors were limited and appeared flat and full. Fresco style echoed Carolingian and Ottonian art.

Illuminated manuscripts were painted in watercolor and ink on vellum or parchment. They were often decorated with gold leaf. As in frescoes, their style continued the manner of Carolingian and Ottoniam art.

Panel painting was done on wood or ceramic tiles. Some panels, especially by Nicholas or Verdun, showed figures having volume and weight with damp, clingy drapery to suggest a body underneath. Verdun's style predicted art of the Gothic period.

9.5.5 Romanesque Minor Art

Different types of Romanesque minor art emerged. The greatest item produced under this heading was The Bayeaux Tapestry (*ca.* 1073–1083). It commemorated The Battle of Hastings of 1066. This wool-embroidered frieze measured 230 feet in length and 20 inches in height. Its style recalled Carolingian and Ottonian art. It showed flat, decorative figures floating over a two-dimensional frontal plane with no suggestion of space or environment.

Also, the Meuse Valley revealed some of the most interesting metalwork. Here, metalwork brought back from the Crusades suggested Mosan sources.

Finally, designs by Renier of Huy revealed a Classic influence. His Baptismal Font figures and animals had weight, proportion, physical density, and balance.

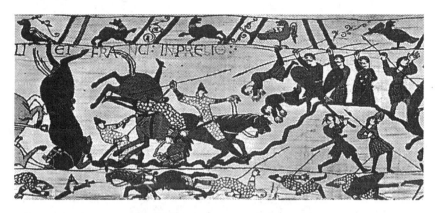

THE ROMANESQUE PERIOD: *The Battle of Hastings*, artist unknown, 1073–83. Wool embroidered on linen. Town Hall, Bayeux.

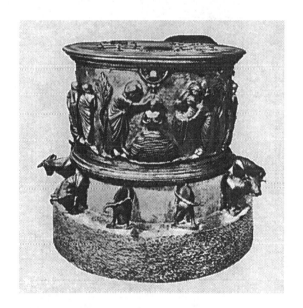

THE ROMANESQUE PERIOD: *Reiner of Huy Baptismal Font*, artist unknown, 1107–18. Bronze. St. Barthélemy, Liége.

9.6 The Gothic Period

9.6.1 Origins

The Gothic period refers to a medieval style of art that lasted from about 1150 to 1500 in the northern European countries and until 1450 in Italy. It marked the final time in Europe when the church was the primary patron of the fine arts before it was replaced by the Renaissance epoch whose kings, merchants, and bankers became the chief sponsors of the creative arts.

The word Gothic means "barbaric," a style that the Renaissance artisans referred to as opposite of the rational, logical, and ordered Antique Classic mode.

9.6.2 Gothic Architecture

Gothic art is most noted for its architecture. Its origins stem from the choir at the Abbey Church of St. Denis, outside of Paris between 1140 to 1144. For the next half-century, the Gothic mode took over the Romanesque in France and ultimately became the new style of the future.

From about 1200 to 1270 there developed what was called "The Age of the Great Cathedrals." Its style spread to practically every northern European country. Its grasp lasted to about 1400 when it eventually, in France, became an ornamental rather than a structural manifestation.

For the most part, Gothic architecture is entirely homogeneous in character. Gothic architecture emphasized interior height, and with this several innovations followed.

The pointed arch might have had its roots in Moslem architecture. Unlike the rounded arch of the Romanesque period which carried its weight and mass outward to the walls, the pointed arch of the Gothic created a downward pressure or thrust that was carried by internal columns or cluster piers. Thus, a heavy column or cluster pier was the only support needed to carry the weight of the rib vault. In the Gothic, walls were not needed for internal support as in the Romanesque. Gothic architecture was characterized by "voids" or spaces over a

skeleton framework. Romanesque architecture was one of solid masses. Many say the Gothic church symbolized the skeleton of Christ, while the Romanesque church was the flesh-body of Christ.

An outgrowth of the pointed arch in Gothic architecture was the rib groin vault, which was made up of a relatively thin covering of masonry over a ribbed structure of pointed arches. The result of using the pointed rather than the semi-circular arch meant that the Gothic architect could build vaults to any ceiling height regardless of the span (width between columns) of arches. The Romanesque architect was always limited by the diameter of arch. Furthermore, because of the nature of the ribbed vault, a thinner coating of masonry to cover the vault could be used, thus combining greater simplicity of construction with a less massive, equally sturdy building.

The flying buttress was a supporting bar of masonry placed on the outside of the church, above the aisles. The flying buttress carried the weight of the internal ceiling rib vaults away from the inside walls to the outside walls and eventually down to the ground. They were an additive to the skeletal frame to insure that the vaults and clearstory walls would not collapse under the downward pressure of the internal rib vaults. The flying buttress was initially used in Notre Dame, Paris in about 1180.

The wall buttress, or bastion, was a vertical pier built onto the outer wall of the building and used to sustain any pressures on the outer walls that might result from the high vaulting (and the flying buttresses). The effect was "rib-like" rather than massive, since nothing was added to the thickness of the outer walls.

More window space was employed during the Gothic period. The Gothic church was often referred to as the skeleton of Christ because of its transcendental, spiritual, light, airy feeling. Window areas replaced hitherto small openings in the thick walls of the Romanesque church. The windows were needed to illuminate the high and lofty rib vaults supported by columns and/or piers below. Since the walls of the Gothic church did not support the weight of the ceiling, larger windows could now be used. One of the most beautiful windows within the Gothic church was the rose or wheel window. This window was usually seen in the westwork facade, and

sometimes in the facades of the transepts. The Gothic church was often called a "spiritual greenhouse."

The westwork facade of the Gothic church became more decorative, ornate, and "sculptural." The portals increased to three, and in some churches portals were introduced into the north and south ends of the transepts. Aside from being further hollowed-out, the portals were often filled with column-bound statues; and bas-reliefs were placed in the tympanums. The towers of the westwork were merged and integrated into the westwork structure and this increased the vertical feeling of the Gothic church.

The compound pier was made up of a cluster of columns (or columnettes). In Gothic times as compared to Romanesque times, the clusters of columns were doubled in order to support the weight and pressure of the rib vault ceiling and the arches above.

The outlines of the stone and masonry in the Gothic cathedral were softened by the diffused light coming through the large stained-glass clerestory windows. The great piers lost their massive look, and the nave vault, with its great height, almost disappeared in a soft bright dusk. The effect was to look upward, from the brightly-painted statues and capitals, the gold altars, etc. to the dim, almost other-worldly upper area, and then to the brilliantly colored windows.

Another outgrowth of the use of the pointed arch was the rect-angular bay. (A bay is the opening between two columns of piers.) The semi-circular arch (and the barrel groin vault) required bays that were equal on all sides, and this limited heights. The pointed arch not only allowed higher vaulting, but reduced the distance between columns, and enabled the builder to construct rectangular bays, since it was no longer necessary for the width of each side to be the same.

Spires, pinnacles, flèches (arrow-like motifs), and polychromatic sculpture, etc. adorned the exteriors of many Gothic churches. Also, the ornate carving of outside stonework which became known as "bar tracery" was observed. Finally, as compared to the Romanesque church, the Gothic church showed a larger apse end (called a "chevet" in French Gothic churches) because of the increase in relics. The choir also increased in size because of the growing importance of music or "plain chant" in the sermon.

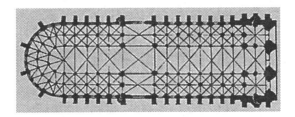

Plan of Notre Dame, 1163–1250.

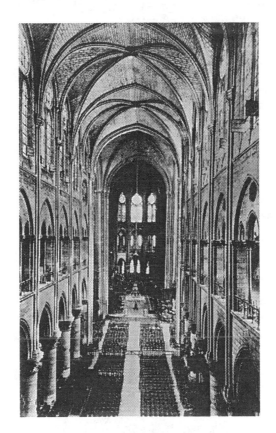

GOTHIC PERIOD: *Notre Dame, Nave and Choir*, artist unknown, 1163–1200. Paris.

The Gothic church had an exoskeleton and was called a "sermon in stone" for repentance and final redemption from sin.

9.6.3 Gothic Sculpture

Gothic sculpture changed considerably from its early flat, formal, stylized, stiff forms to more independent, rounded, organic free-standing imagery. By 1300, sculpture had superceded architecture in importance. For the first time in medieval art, sculpture freed itself from illuminated manuscript influences.

There were many types of Gothic sculpture:

1. Architectural themes—free-standing and relief works in and outside the church

2. Devotional work such as free-standing images of the Madonna and Child, Crucifixes, and Pietas

3. Tomb effigies usually of English or French nobility placed on floors of churches

4. Altarpieces and shrines primarily done in Germany

5. Gargoyles or fantastic beasts or chimera which served as rain spouts or merely looked out from their high perches on church roofs to protect the church.

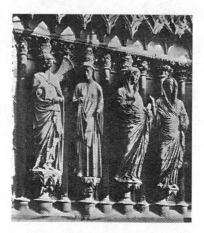

GOTHIC PERIOD: *Annunciation and Visitation*, **1225–45. Stone. Reims Cathedral.**

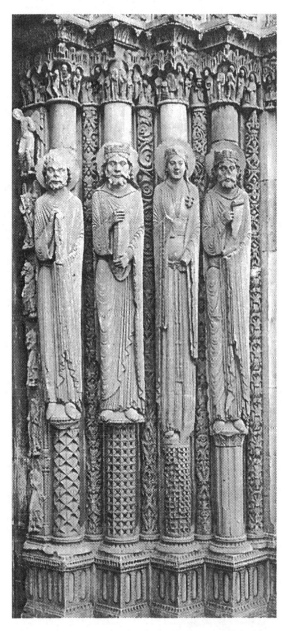

GOTHIC PERIOD: *Chartres Cathedral Statue*, artist unknown, 1145. Stone. Chartres Cathedral.

Stone and wood were the most popular materials. These were polychromed in fresco-like paint (for stone) or tempera (for wood).

9.6.4 Gothic Painting

Gothic painting, unlike sculpture and architecture, had not yet reached a clear-cut stage of development by the Thirteenth Century. Although churches continued to be lavishly decorated, the paintings still revealed the strong influence of a Byzantine style, which expressed itself in flat, linear, two-dimensional figures and the lack of a background setting. Gradually, the affect of Gothic sculpture appeared in painting, not only in terms of depth and body attitudes, but to provide a spiritual and lyrical quality.

In the North, the emphasis on spirituality and the illuminated manuscript tradition continued to reveal an elongance and ornateness.

Finally, the growing effect of Antique Classic modes made evident by the presence of such sites as Pompeii, Boscoreale, and Herculaneum led to a more "humanistic" interpretation of figures.

There were three types of Gothic painting:

1. Gothic panel painting—this mode emerged in Italy, especially Florence and Siena. The use of oak panel, coated with a smooth gesso slip and painted in tempera was used. The so-called Italo-Byzantine style was noted, combining Classic and Byzantine art. From this, two manners evolved:

 a. The Proto-Renaissance (1250–1350) which followed the Classic imagery

 b. The International Style (1330–1420) which was more northern-inspired style-decorative, polychrome and picturesque

2. Gothic manuscript painting which was made in urban workshops as well as by monks in countryside monasteries.

 The laymen who made manuscripts were the ancestors of the printers and publishers of the Renaissance and later periods. Not only were manuscripts done anonymously but now ac-

tual names appeared such as the Master Honoré, Jean Pucelle, and the Limbourg Brothers.

3. Gothic fresco painting that occurred primarily in Italy—Florence, Siena, and Rome. The Classic Antique was influential here (Florence and Rome) as well as the International Style (Siena). Noted artists were Giotto, Lorenzetti, and Cavallini.

GOTHIC PERIOD: *David and Goliath, from the Prayer Book of Philip the Fair*, **Master Honoré, 1295. Painting. Bibliotèque Nationale, Paris.**

GOTHIC PERIOD: *February, taken from the Very Rich Book of Hours of the Duke of Berry*, The Limbourg Brothers, 1415. Painting. Musée Condé, Chantilly.

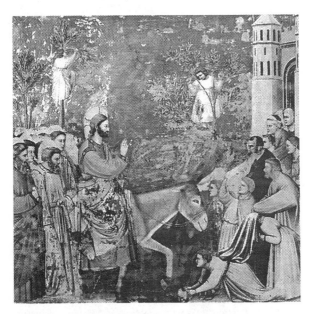

GOTHIC PERIOD: *Christ's Entry into Jerusalem*, Giotto, 1305–6. Painting. Arena Chapel, Padua.

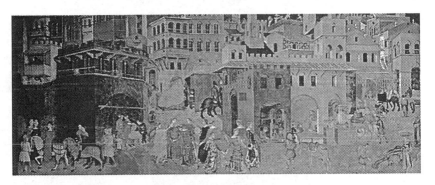

GOTHIC PERIOD: *Good Government*, Ambrogio Lorenzetti, 1338–40. Painting. Palazzo Pubblico, Siena.

9.6.5 Gothic Stained Glass

As the importance of the clerestory and rose windows emerged in Gothic architecture, the art of stained glass developed rapidly and eventually replaced illuminated manuscripts.

Gothic stained glass makers worked with their architectural peers to produce a mode of art that became an individual craft. It was made of tinted glass held together by lead strips. Details of hair, eyes, and drapery pleats were actually hand-painted onto the glass.

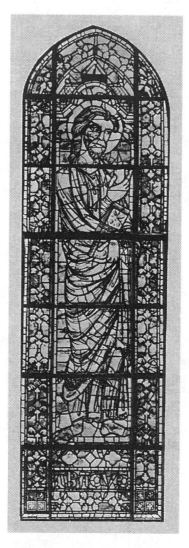

GOTHIC PERIOD: *Habakkuk*, artist unknown, 1220. Stained glass. Bourges Cathedral.

CHAPTER 10

The Renaissance Period

10.1 The Renaissance Manner

Historians set the beginning of the Renaissance period at the start of the Fourteenth Century in Italy, and somewhat later in the North. Historians see the Renaissance as a time of change, when the medieval culture of a feudal and clerical aristocracy gradually changed to a culture of urban laymen whose surroundings, personal life, and professional interests were different from the landed gentry they replaced. The Renaissance was the time of a rising middle-class whose growing wealth and ambition encouraged a culture with a distinctive humanist emphasis, a concentration on the individual, and a belief in the values of this world.

The Renaissance (rebirth) marked a re-discovery of Antique Classic art and literature. It developed an interest in man and the realities of this world. All things in life, as in art, were measured by the human standard. Man saw beauty in the Renaissance as a reflection of himself. Beauty and dignity of humanity were stressed. Nature was explored.

In the North, especially Flanders, which became not only a leading economic center but a cultural and artistic one, the emphasis was on the real in art. Its leading proponents were the painters. In Italy, emphasis on the real was equally strong, but it was the sculptors who led the way.

Artistically, the Renaissance period was noted for its overall emphasis on harmony, sequence, and balance.

The Renaissance artist saw his work not only in terms of reproducing what was in the past but in the light of his own attitude. He was a Classicist who used his knowledge of the past to create a new art.

In the Early Renaissance (*ca.* 1400–1500) the Italian city-states, with their middle-class aristocracies, grew in wealth and power. The lack of a strong central government in Italy had put power into the hands of local rulers (like the Medici family in Florence). They wanted to solidify their position with public monuments such as buildings and sculpture.

10.1.1 Early Renaissance Architecture

Architecture drew not only from the Medieval past but more readily from Antique Roman ruins. Such architects as Brunneleschi, Alberti, and Michelozzo created buildings (churches, chapels, palaces, hospitals, etc.) that mirrored Antiquity. Their work achieved a mathematical clarity via a logical design and spatial organization based on the human proportion.

10.1.2 Early Renaissance Sculpture

It was in sculpture, in Italy, that changes occurred. Figures, often life-size, became the popular item. Nude images of both sexes were noted for the first time since Antiquity.

Guilds and private patrons commissioned them. Protraiture, religious, and mythological themes were most popular and heroes were memorialized through tomb sculpture and equestrian imagery. Hollow-cast bronze, marble, terracotta, and some polychrome-gilded wood figures were fashioned. The most noted artisans were Ghiberti, Donatello, the Robbia family, and Verrocchio. Their themes emphasized realism, correct scale, aerial perspective in relief work, and a psychological insight not seen in Antique art.

10.1.3 Early Renaissance Painting: Italy and the North

Painting in the Early Renaissance was noted in Italy and the North (Flanders, France, and Germany).

In Italy, fresco and panel painting continued. Popular were religious scenes, portraiture, and by mid-century, pagan mythology. Some of the more well-known painters were: Masaccio, Fra Angelico, Piero della Francesca, the Bellinis, Botticelli, etc. Their work showed an interest in correct linear perspective, aerial perspective, correct interpretation of anatomy, landscape backgrounds, triangle-oriented compositions, and light emanating from a specific source outside the picture frame. Figures revealed weight, volume, and plasticity and looked tactile (touchable).

Outside Italy, in the North, Flemish artists—the van Eycks, van der Weyden, van der Goes, Bosch, etc.—derived their inspiration, not from Classical art, but from illuminated manuscripts. They displayed a strong interest in accurate realism–almost microscopic-and developed the oil technique with the use of transparent glazes placed over an underpainting of tempera on gesso coated panels. No fresco art existed in the North. In addition, their scale was incorrect; their portraits did not flatter the sitter; no haloes were used; and they had a disguised symbolism to signify religious events (dog, fidelity; lilies, purity of the Virgin; fenced-in gardens, Mary's Virginity, etc.).

In France, there developed a combination of Flemish and Italian motifs as in the work of Fouquet and The Southern French Master, While in Germany, a strong influence of Flemish realism and earlier International Gothic Style could be observed in the oil of Lochner and Witz.

During the Early Renaissance, the Flemish artists derived their inspiration, not from the revival of interest in Classic art that was taking place in Italy, but from the late French Gothic style. However, like the Italians, the Northern artists displayed a strong interest in realism. Flemish art was realistic, with figures drawn from the real world, integrated into plausible landscape (or interior) settings. It was only as the Renaissance continued that Flemish art entered the "Italianate" phase, in which the artists came under the influence of the Italian Renaissance painters. But this did not occur until near the end of the Fifteenth Century. However, from 1400 onward, the Flemish style of painting (also called the "Northern" style) was followed not only in Flanders, but in Germany, France, and even in Spain.

Only Italy followed her own mode.

Part of the Flemish inheritance from the Gothic era was the emphasis on landscapes and realistic settings that had been the work of the Late Gothic manuscript illustrators such as the Limbourgs in France. At the start of the Renaissance, there arose in Flanders an important artistic school of painters in the Flemish city of Bruges. The artists combined Gothic traditions with the new interest in realism, and developed a style that was singularly Renaissance. Some aspects of that style were:

a. Religious works set in naturalistic landscapes or detailed interior settings.

b. Development of donor portraits, where the portrait of the donor is painted in a scene together with religious figures.

c. Use of "transfigured" symbolism in the painting. Everyday objects were given symbolic meanings. (Clear water was used to indicate not only water, but the purity of the Virgin Mary.)

d. A desire to portray the world of nature as it was exactly, sometimes even over exaggerating reality, a technique which may call "naturalism."

Technically, there were many significant points about the "Northern" style of painting, some of which were:

a. Unlike the Italians, who directed all parallel lines (lines at right angles to the frontal plane) toward a single vanishing point on the horizon, the Flemish set up an imaginary vertical axis in the middle of the painting, and lines from the sides converged on this axis at many points.

b. The effect of space was achieved by the use of broadly draped figures. It was also achieved by the use of "atmosphere." ("Atmosphere" was rendered by the Flemish precisely as it is in nature, causing distant objects to appear less clear and less colorful than closer ones.)

c. The Flemish artist always used a clear, precise, sharply-focused, calligraphic (linear) outline for his figures. Unlike the Italian painter, he did not allow outlines to merge with the surroundings.

d. Flemish figures do not have the "solidity" of the Italian Gothic figures in spite of the heavy draperies. They tend to appear less "solid" and more "flat" than the Italian ones.

e. The Flemish artist used color in a specific way. natural boundaries were used to divide the picture into three sections:

 1. middle ground

 2. foreground

 3. distance

Distance colors were kept to the blue-greens; warm tones and strong contrasts were used for the foreground; and the middle ground contained the same hues as the foreground, but neutralized in tone.

f. The Italians based their figures and faces on Classic models, but the Flemish artist painted people as he saw them, with all the wrinkles, blemishes, etc. just as they appeared in real life.

The technique of oil painting that was invented in Flanders during the Renaissance has been credited to the van Eyck brothers. Although the process they used is not the same as that of the modern artist, it resulted in a tremendous change from the early techniques. The Flemish oil painting process was as follows:

1. A wooden panel was covered with a fine cement surface. (Most Flemish paintings were made on wood paneling.)

2. The picture was then drawn on the surface with pen and ink, and the shading done in neutral monotone.

3. Color was applied by using a thick transparent paint of the consistency of a glue, called a glaze, or varnish.

The whole effect was to produce a painting that had a jewel-like sheen, and one which would last indefinitely. Correction was impossible and the painters had to work slowly and with much care. Oil painting did not come into use in Italy until 75 years later, and Leonardo da Vinci was one of the first to use it. It was in Venice that oil painting was immediately adopted, and the Venetian painters explored the limits of the medium, developing materials and techniques that are still in use today. The damp climate of Venice had made water-based paints difficult to use and preserve and the Venetians eagerly accepted the new oil medium brought to them by the Italian painter, Antonello da Messina, in 1475, from Flanders where he had been studying.

10.2 Early Renaissance Prints

Most of the Early Renaissance woodcuts came from northern Europe, where the wood block process originated. Block-prints were stamped on paper, hand colored, and mass-produced.

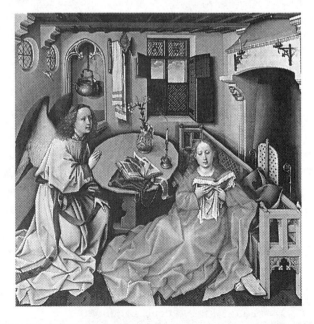

RENAISSANCE PERIOD: *Annunciation*, The Master of Flémalle (Robert Campin), 1425–1428. Painting. The Metropolitan Museum of Art, NY.

The Early Renaissance printmakers wanted a more permanent material from which to fashion their designs because the wood block often wore out. As early as 1400, engravings appeared. The earliest showed the style of Flemish painters and Upper Rhine artists such as Schongauer.

Drypoint then grew out of the engraving technique. However, the artist did not cut grooves in the metal plate. Instead, he would scratch the surface of the plate with a fine metal needle. The Master of the Hausbuch exemplified this manner.

10.3 High Renaissance Italian Art

High Renaissance (1500–1520) Italian art fulfilled many aesthetic, scientific, and ideological concepts formulated and innovated in the Early Renaissance period. It brought to maturation the ideas of the Quattrocento. Now, the artist and architect became a true individual—free from any bonds with the medieval past.

The High Renaissance represented a shift from Florence to Rome. Under the inspiration of Pope Julius II, Rome reached new heights first in Italy, and then the tide spread to the remainder of Europe. However, many historians mark the conclusion of the High Renaissance period as 1520 (coinciding with the death of Raphael). Others feel that the Sack of Rome in 1527 by the armies of the Spanish Emperor, Charles V, marked the end of the phase.

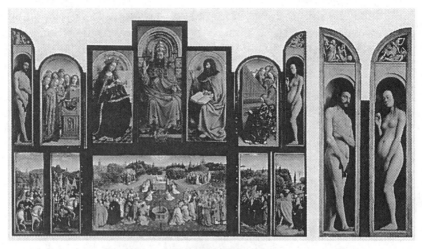

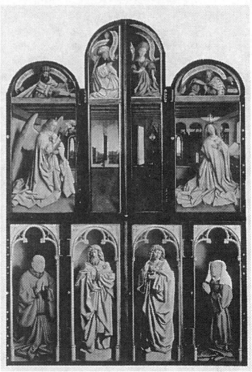

RENAISSANCE PERIOD: *The Ghent Altarpiece*, Hubert and Jan van Eyck, 1432. Oil on panel. St. Bavo, Ghent.

10.3.1 High Renaissance Italian Architecture

High Renaissance Italian architecture shifted its emphasis from Florence to Rome and Venice. Religious themes (churches and chapels) and secular buildings (palaces, offices, libraries) continued to be built for wealthy patrons. As in the Early Renaissance, materials and styles remained the same. However, there were some changes such as less use of rustication (heavy stone work); central plans were more popular; the circle-in-the-square organization increased in church ground plans; balustrades (posts with railings) were introduced; and the buildings appeared more ordered, clear, and harmoniously proportioned. The most noted architect was Bramante.

10.3.2 High Renaissance Italian Sculpture

The work of Michelangelo highlighted High Renaissance sculpture. His commissions were overwhelming, especially by the papacy. His well-known Pietas, David, and figures for the Tomb of Julius II showed his individual bent of freeing images "imprisoned" in the stone. They were heroic, monumental, muscled, and filled with a pent-up expressive emotionalism.

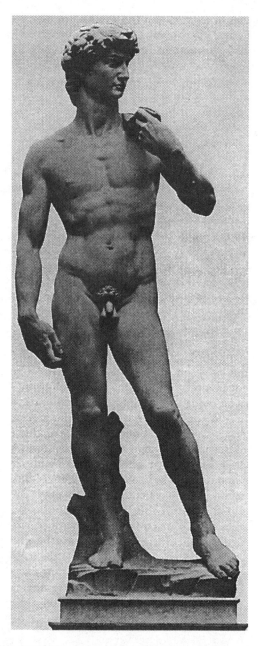

RENAISSANCE PERIOD: *David*, Michelangelo, 1501–4. Marble. Academy, Florence.

10.3.3 High Renaissance Italian Painting

Three artists captured the style and spirit of High Renaissance painting: Leonardo da Vinci, Michelangelo, and Raphael.

Leonardo brought a sensitive, mystic beauty, and deep psychological warmth to his figures that were bathed in sfumato (smoky) effects and enwrapped in a chiaroscuro (dark and light) shading.

RENAISSANCE PERIOD: *Adoration of the Magi*, **Leonardo da Vinci, 1481–1482. Painting. Uffizi Gallery, Florence.**

Michelangelo's Sistine Chapel showed heavy muscled, heroic, monumental forms that mirrored his sculpture. And Raphael's Madonna and Child themes revealed a sublime beauty, ideality of human proportion, and physical perfection.

New design elements were formulated such as the pyramidal composition and two-point linear perspective.

10.4 Later Renaissance Art

Later Renaissance art (*ca.* 1520–1600) continued the ideals set in the High Renaissance period in Italy. However, within its development there emerged Mannerism.

Mannerism, as a separate mode, was bound up with politics, social conditions of the time, and religion. The Mannerist style fitted in well with a new trend in the Catholic world. In defense against the Protestant Reformation, the Catholic Church stressed the mystical and supernatural parts of religious experience. The Mannerist style meant the absolute end of the Classical balance of the High Renaissance. Thus, "the rules of the ordered, rational, and logical Classic Renaissance" were replaced by an irrational, illogical, and anti-Classical outlook toward the world.

Historically, the infamous Sack of Rome on May 6, 1527 by Charles V perhaps generated Mannerism. As a result, artists fled The Eternal City and sought refuge, if not patronage, elsewhere. All the creative arts were affected.

10.4.1 Later Renaissance and Mannerist Architecture

In Italy, Late Renaissance architectural designs of the Early and High Renaissance continued. Michelangelo's creativity introduced The Colossal Order and paired columns into exterior wall surfaces. While Palladio adhered to the Classic Roman style and formulated an individual Palladian Order.

In France, the Italian Renaissance mode was married to a pre-existing Gothic expression of medieval castles with turrets, towers, spires, sloping roofs, pavilions, pointed arches, and sculpture used as decoration.

Manneristic architecture in Italy was used only on a secular level. Such architects as Vasari, Romano, and Ammanti were opposed to Classic Renaissance principles. Their designs were ambiguous and disproportionate. Classical elements were illogically conceived such as spacing doors, windows, columns, etc. irregularly and having columns, piers, etc. support arches in an ungainly way.

10.4.2 Later Renaissance and Mannerist Sculpture

Later Renaissance sculpture was still dominated by Michelangelo, but his forms now possessed more tension. They looked unbalanced, restless, and anxious. Their forms emerged partially from the depths of the stone—incomplete, unfinished—as if ambiguous as to their own meaning.

Still other Mannerist sculptors, Primaticco and Giovanni da Bologna, incorporated the tensions of Michelangelo. Their works displayed elements typical of Mannerism, that is, elongated, svelte torsos, pin-heads and exotic, twisted poses and affected gestures. Mythological subject matter was popular.

10.4.3 Later Renaissance and Mannerist Painting

Later Renaissance painting continued the work of Michelangelo, though his themes now verged on the grotesque as in The Last Judgment. They showed his growing pessimism against the corrupt rule of Pope Paul III and the growing unrest in Italy because of the Sack of Rome and the spread of Protestantism. However, there did emerge a glimmer of light in the innovative work of Correggio whose experiments in nocturnal lighting effects and illusionistic fresco painting heralded the advent of the Baroque or seventeenth century.

In addition, Mannerism in painting arose between 1520 and 1600. This style, as in architecture and sculpture, reacted against all artistic principles of the High Renaissance. Its bizarre themes, ranging from biblical and mythological to portraiture revealed a strange, personal subjectivity and artistic incongruity. Among its more salient traits were: chaotic figure arrangements; discordant, asymmetrical, and obscure compositional spatial interpretations; discordant and garish colors; and exaggerated, if not, frantic image gestures and actions. Such artists as Pontormo, Parmigianio, and Bronzino were noted.

An individual manner, sometimes called a "relaxed style," evolved in Late Renaissance painting in Venice. Among the more well-known artists were: Giovanni Bellini who painted sweet, idyllic Madonna and Child themes; Titian, who excelled in psychological interpretations through his portraits; Veronese who developed flat color tones

and modeled his figures in shadows and highlights; and Tintoretto whose exaggerated configurations whirled in an emotional ecstasy. Yet all abided by a formula of color, golden light, and texture which were salient traits of Venetian art.

Outside Italy, in Later Renaissance painting, there emerged a tradition headed by the German Grünewald, Dürer, and Holbein Grünewald related to Flemish symbolic painting in his expressive, detailed Isenheim Altarpeice. And Dürer, through his oils and graphics, created subjective, poignant works that combined the precise, linear northern manner with an Italianate flair for volume and mass. Holbein painted portraits of famous international rulers, scholars, and prelates in a deep, psychological, subjective way.

Netherlandish painters conceived non-religious themes. The influence of Italian High Renaissance art was commingled with a northern love of detail and disguised symbolism. For example, Brueghel painted genre themes with peasants that were symbolic and moralistic. While the Dutchman, Aertsen, developed a system of genre and still life interpretation alluding to earlier Flemish covert symbolism.

Finally, English Late Renaissance painting was marked by Holbein's contributions and those of the native-born Hillard whose svelte, elongated figures reflected Italian Mannerist art learned at the School of Fontainbleau.

10.4.4 Later Renaissance Graphic Art

Later Renaissance graphic art centered around the work of Dürer. His proto-expressionistic themes, done in woodcut and engraving, continued the northern symbolism. With a precise love of decorative detailism and incisive linearity, combined with an Italianate mode for mass and volume, he depicted sacred and secular subjects with a profound subjectivity.

10.4.5 Later Renaissance Minor Art

Later Renaissance minor art was exemplified in the work of the sculptor/goldsmith, Cellini. He established a Florentine tradition of delicacy, creating the most skillful, charming themes. His work related to Mannerism via his elongated, sometimes illogical figures.

CHAPTER 11

The Baroque Period

11.1 Baroque

11.1.1 Origins

The Baroque period refers to the Seventeenth century. The word "baroque" from the Portuguese "barrocco," meant an irregularly shaped pearl, referring to the fact that so much of the art of this period was curved and active in style and content.

The Baroque period came after the storm of the Reformation which had been followed by the equally stormy Counter-Reformation. Catholic and Protestant had fought and the result was not victory, but a standoff. Catholic Europe (France, Spain, Italy, etc.) remained within the sphere of the Church, while Protestant Europe (Holland, Germany, England) followed a new course.

Baroque art, in those countries with a strong monarchy, combined the aristocratic and the religious. In the bourgeois countries like Holland, it devoted itself to burgher patrons and naturalistic subjects.

In Italy, the Baroque period was first and foremost a time when art was dedicated to the propagandizing of the Roman Catholic Church. Italian Baroque art was supposed to reinforce the emotional appeals made to the heart by the trenchant sermons of the Jesuits.

The Baroque period was an outgrowth of the Renaissance style. Some art historians believe that it had its origin in the work of Michelangelo who set the tone, if not the manner, of the Baroque. Baroque art, in all its manifestations was dynamic, theatrical, and powerful. Artistically, it manipulated mass, light, space, and physical volume.

The Baroque period saw the artist using symbolism in his own way rather than conforming to previously dictated rules. As a result, the symbolism (iconography) of the Baroque era was less obvious and more individualistic than it had been during the Renaissance (or the Medieval) era. However, by each artist following his own particular idea, the universal nature of Church symbolism that had been sustained throughout the Renaissance was gradually dissipated, and the power of the Church to regulate and dictate artistic content and form was thus lessened.

Of great significance in the Baroque era was the trend toward theatricality. The baroque artist was first and foremost a showman, dedicated to moving his viewers, and persuading them that what they saw was "reality" even if they knew it was not. The use of such methods as "constructed perspective"—the artist creating an effect of great distance when it was actually only a fraction as much—is part of the Baroque Age. As one historian puts it, the object of the Baroque was to persuade that the transcendental was "real," and that religious art was an art of the "real" rather than the imaginary. Because of the great popular interest in the theatrical qualities of Baroque art, many artists used their abilities to create stage scenery and theatrical effects.

The noted art historian, Heinrich Wölfflin, his *Principles of Art History*, cites five characteristics of Baroque architecture, sculpture and painting:

1. Painterly—the edges are fuzzy and there is more feeling of paint per se. Baroque artists omitted the use of lines, and thereby played up the large volumes within their compositions. These volumes appear massive and weighty in their quasi-abstract quality.

2. Recession—a depth within the composition is achieved by leading the eye into the picture. The Baroque artist placed his figures and forms in a diagonal position rather than lining them up in rows one behind the other, and in this way, the viewer could "enter" the picture foreplane and become more involved in the composition.

3. Open—figures in the composition seem to be standing apart from each other and set back in space. In architecture, as well as art, Baroque space seemed infinite and without clearly defined boundaries, unlike the more definite area assigned to the Renaissance works.

4. Unity—figures and forms are solidified into masses and cannot be separated from the whole.

5. Unclear—it is difficult to distinguish representations in the composition. Because of the de-emphasis on the line much of the detail is unclear in Baroque art. In architecture, the complexity of the ornamentation and massiveness of the building segments often obscure the outlines of the whole structure.

The purpose of the Baroque manner was to emphasize emotion at the expense of other artistic considerations. The illusion and theatrical accents were emphasized to heighten the mood, drama, and religious emotion to be aroused by the composition.

With these traits in mind, let us turn to some examples of architecture, sculpture, and painting within the Baroque period.

11.1.2 Baroque Architecture

The two most typical Baroque buildings were the church and palace. The church was the symbol of ecclesiastical activity; and the palace was the symbol of the power of the monarchy. These structures were aimed at length and breadth. They were designed to hold large numbers of people. Their effect was grand, flamboyant, and massive.

Baroque architecture emphasized the monumental. Every part of a Baroque building submitted to some form of decoration, either sculptural or painted.

Classic forms in the Baroque were decorative rather than functional. The façades of churches (especially in Italy) became a false front whose only purpose was to interest and attract the beholder. Illusion gave the feeling of space where there was none. Rough appearing surfaces were carved, straight columns were graduated and twisted. The effect was to make the viewer experience a sense of unreality. One's senses were staggered by detail added to detail. The onlooker was invited into the structure, not to be a part of it, and be dazzled if not overwhelmed.

In Italy, Baroque architecture related to the Counter-Reformation. Noted architects—Bernini, Borromini, and Guarini—produced exciting, emotional churches on a theatrical, complex, and grand scale. Outside Italy (France and England) the emphasis was on palaces and secular buildings that related more to Classical Renaissance themes. The term Classical-Baroque was used to determine their style.

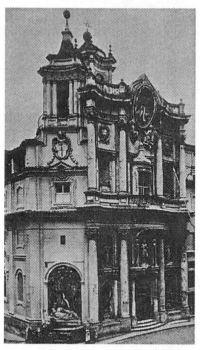 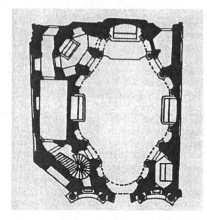

BAROQUE PERIOD: *Facade and Plan*, **Francesco Borromini, 1638–67. Stone. San Carlo alle Quattro Fontane, Rome.**

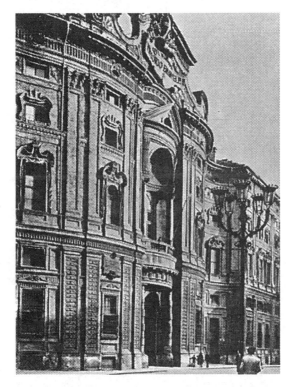

BAROQUE PERIOD: *Palazzo Carignano*, Guanno Guanni, 1679. Stone. Turin.

11.1.3 Baroque Sculpture

Baroque sculpture emphasized movement and fluidity at the expense of the Classic sense of repose and plastic unity. Figures were set into motion by various directional thrusts. This was intensified by swirling patterns of cloth and hair. Draperies were filled with passionate and dramatic action, somewhat reminiscent of the Late Gothic style. Contrasting materials (marble with gilt) were used to heighten the effect of the composition. The Baroque expression of pain mixed with ecstasy appeared on faces, combining the spiritual with the sensual.

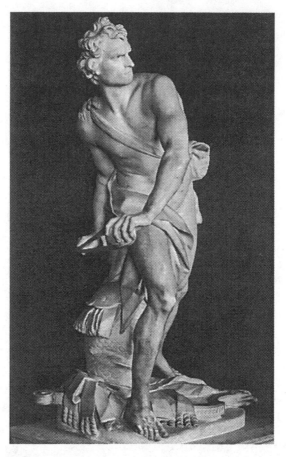

BAROQUE PERIOD: *David*, Gianlorenzo Bernini, 1623. Marble. Borghese Gallery, Rome.

The most well-known and influential sculptor that emerged as a powerful and emotive force during the Baroque was Bernini. His mode was continued well into the Rococo period.

11.1.4 Baroque Painting

Baroque period painting exhibited many individual styles throughout western Europe, as each country had a unique expression.

In Italy, two directions evolved in painting:

1. an academic or "backward-looking" approach as in the eclectic art of the Carracci family

2. a progressive or "forward-looking" manner as in the art of Caravaggio. The former derived its inspiration from High Renaissance artists; while the latter was entirely original in statement, purpose and style.

The progressive style became dominant. It emphasized naturalism, clarity, and dramatic chiaroscuro effects within tenebroso (dark, murky) settings. Here, anecdotal-religious and secular genre themes emerged.

Of course, alongside these existed the Italian fresco tradition in the works of Reni and Il Guercino. Their names were illusionistically represented as they opened-up wall and ceiling space, created dynamic foreshortened effects and dark and light accents.

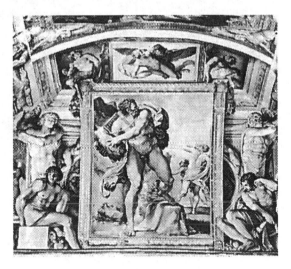

BAROQUE PERIOD: *Ceiling Fresco*, Annibale Carracci, 1597–1601. Painting. Gallery, Palazzo Farnese, Rome.

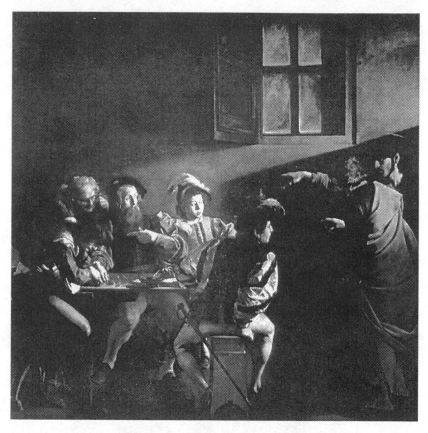

BAROQUE PERIOD: *The Calling of St. Matthew*, Caravaggio, 1590–1598. Oil canvas. Contarelli Chapel, San Luigidel Francesi, Rome.

Spain produced two modes:

1. El Greco rendered a deep-seated religious mysticism that echoed the Spanish Inquisition

2. Valazquez evoked a Caravaggio-like naturalism in his early work and an Italianate coloratoura in his later court paintings for Philip IV.

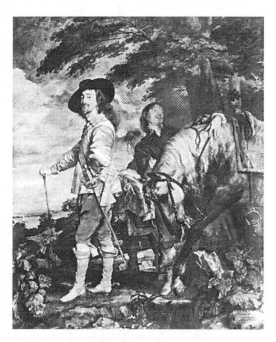

BAROQUE PERIOD: *Portrait of Charles I Hunting*, **Anthony Van Dyck. 1635. Oil canvas. The Louvre, Paris.**

Flemish art showed a lusty, polychromy and fluid, rapid brush strokes in the oils of Rubens and Van Dyck. While Dutch art produced private images in Rembrandt and public images in Hals alongside "schools" of genre, landscape, and still life painting.

France contributed an Academic-Classical style in Le Brun's art as well as an anecdotal humanistic naturalism in the oils of La Tour and Le Nain. Landscape was also depicted in a Classically contrived way in Poussin's themes and in a pictorial, pastoral mode by Claude Le Lorrain.

Finally, England echoed the work of the Fleming, Van Dyck, who established England's future portrait tradition.

11.1.5 Dutch Art

The successful revolt of Holland against the Spanish monarchy—and the Catholic Church—in the late Sixteenth Century put into power

a conservative Protestant middle class. A financial crisis in southern Europe had shifted the financial center from Italy and Germany to Holland, and Amsterdam became one of the richest capitals in Europe.

As a result, it was the Protestant (rather than the Catholic) and the middle-class (rather than the aristocratic) viewpoint that prevailed in Holland during the Seventeenth Century. Up to that time, it had been ninety percent Church and ten percent nobility who had sponsored European art. Now, at one stroke, both sources were denied.

However, the increasingly wealthy Dutch burghers soon became enthusiastic buyers of art, but their method of patronage was quite different from the Church or nobility. Firstly, the burgher patrons wanted to see a finished product, rather than give a commission to an artist to have a painting done. Painters, therefore, had to paint before selling rather than afterwards. The painter was free to paint whatever subject he chose, but he would more likely paint what "sold" well. The outcome was a group of "little Dutch masters," each of whom specialized in one type of painting that he knew he could sell easily. Soon there was a "school" of painting in every major city in Holland. A variety of styles developed, together with many able artists. However, there were a few artistic giants among them, and the greatest of these was Rembrandt.

The attitude of the Dutch Protestants toward art was quite different from that of the Catholics. Protestantism had no background in Classic thought (such as Aristotle and Plato), and furthermore, the Dutch Protestant did not care for the symbolism and iconography so carefully built up by the Church during the Middle Ages. Rather, the Dutch Protestants felt that Medieval Church literature and decoration had perpetuated legends and discouraged thought. What the Protestant recognized was worldly success as a sign of God's favor, and that his life, his land, and all its surroundings were good and worthwhile. As a result, Dutch art was rooted in the "real" world, of "real" individuals, rather than the "ideal" world, and "idealized individuals" of the Italian Baroque. Even religious paintings were rooted in the real Dutch world, and the individuals portrayed were easily recognizable as people whose faces bore human rather than idealized markings.

11.1.6 Dutch Baroque Painting

Many different types or levels of Dutch painting arose during the Baroque period.

a. Group Portraiture – The interest in group portraiture came from the Northern schools of portraiture. Many Dutch painters created group portraits of shooting companies, guilds, fraternities, merchants, and societies. Rembrandt and Hals were two of Holland's best group portrait painters.

b. Genre Painting – Genre means "race, kind, species." More specifically, Dutch genre painting depicted common everyday man in common everyday activities. There were many degrees of genre painting. For example, Vermeer painted "classic" environs for his impersonal, monumental figures; Terborch showed the life of the burgher class in all its personal manifestations; Steen depicted a more casual family arrangement or merry-making and over-all good humor and mirth; De Hooch took the viewer into the personal abodes (architecturally formal) of the middle-class Dutchman; and Brouwer and Ostade concocted a low-life gentry of brawling tavern drunks or just sick people. These genre themes—no matter what level—were pervaded with a deep chairoscuro effect, pronounced realism and a warm, human, story-telling, narrative appeal. They were small in size, meant to be hung in Dutch homes, and were a perpetual reminder of how Baroque Holland lived.

c. Landscape Painting – Three types of Dutch landscape painting emerged: 1) actual landscape accounts, 2) cityscapes, and 3) seascapes. Jacob van Ruisdael was a dramatic portrayer of pure Dutch landscapes; Hobbema painted panoramas with low horizon lines; Jan van Goyen created landscapes and seascapes that were pervaded with a suffused, golden transparent light; Vermeer showed quiet views of Delft and harbors; while Van der Velde often painted wild, theatrical, emotional seascapes with violent storms and rain-laden skies.

d. Still-Life Painting – In Dutch painting many types of still-life paintings arose:

1. The Vanitas Portent Theme. This showed burnt candles, hour glasses, skulls, watches—all of which were symbols of death and man's passing from mortal life into a spiritual one. They symbolically meant the quick passing of mortal life. Other types of vanitas such as books, musical instruments, and tools related to the arts; money, purses, coins, precious shells and stones refer to power and wealth; and dice, cards, drinking goblets, food indicate pleasure and good times. In essence, the vanitas painting warned the Dutchman to seek religious piety and prayer, or he will be punished in the afterlife because of a sinful, mortal existence. Vanitas painting contained portents of evil.

2. Piece Still-Life Painting. Taken collectively there were: banquet pieces with fruit, glass and china asymmetrically placed on elaborately set table tops; flower piece paintings with decorative ornate, colorful bouquets of freshly-cut flowers placed in porcelain and silver vases, sometimes with seashells and insects in the painting; and breakfast-piece paintings with fish and shellfish. The early style, as exhibited by Pieter Claesz, had a high horizon line or vantage point from which the observer looks down upon the still-life; while the later manner as seen in Willem Heda's oils was conceived at eye level. Still-life paintings as in Willem Kalf's themes are splendorous in their physical display of still-life motifs usually placed on the Oriental (Persian) carpet, sharply lit by studio light, and all placed against a somber background—porcelain bowls, lemon peels, lobsters, "rohmer" glasses, and shells are some of the favorite items used here; and lastly, fruit still-life paintings per se which originated in style from medieval art and later influenced the painting of Chardin and Cezanne.

e. Church Painting – Emanuel De Witte and Pieter Saenredam painted interiors of Dutch churches. These vast interiors of "hall" churches were architectonically conceived, using small figures for scale.

f. Romantic Dutch Painting – This refers to Dutch artists influenced by Italian Baroque painters such as the Carraci and Caravaggio. Their style combined the Classic-Roman with Dutch realism. The following is a list of characteristics of the Dutch Romantic tradition.

 1. A more subtle use of chiaroscuro—not as vivid in contrasts as true Italian art of the Baroque.

 2. More detail and gestures related to reality and the world of humanism.

 3. Portraits taken from life, not the ideal Classic-Antique past.

 4. Warmer colors, more polychromatic and less mono-chromatic tones.

Such artists from the Romantic Dutch school were Pieter Lastman—the teacher of Rembrandt; Adam Eisheimer—a dramatic landscape painter; Honthorst and Terbrugghen—members of the Utrecht (or "hidden light") School—influenced by Caravaggio in their use of chiaroscuro effects, tactile smooth figures, and employment of deep purple tones.

11.2 The Rococo Period

11.2.1 Origins

The Rococo period refers to the Eighteenth Century. The word rococo comes from the French "rocaille," meaning shaped like a shell. The shell shape was a favorite motif in Rococo ornamentation which was frequently composed of shells and stones. In essence, the Rococo period signifies the late phase of the Baroque period.

Rococo was a gentle art. It found the graceful, poetic style of the Venetian Bellini more to its taste than the intensity of Caravaggio. It

preferred the freer figures of Rubens to the monumentality of the Carracci.

The Rococo revealed an increasing influence of women's taste. The once pompous, heavy forms of the Baroque now became light and elegant. Rococo appealed to a lighter mood. The beauty of women, dressed and undressed, became the subject of many of its paintings and sculptures. In landscape, the time was always summer, the place a garden in bloom, figures engaged in mild flirtations or love making. War and religion were displaced by a dream world, peopled with real or mythological figures.

The Rococo period was the final genuine art style in Europe in which architecture, sculpture, painting, and the decorative arts partook of the same direction and expression.

In style, for example, brocades and silks were used instead of the velvets of the Baroque. Lighter color schemes of blues, pinks, and white replaced the darker colors of the Baroque. The love for the ornamental was seen in the undulating S-shaped motifs, the insistence on curves, the asymmetrical shapes, and the use of shells, flowers, seaweed, etc. as part of its design.

The Rococo saw the introduction of new techniques such as pastel and porcelain—media which revealed the growing sophistication and daintiness of Rococo taste.

11.2.2 Rococo Architecture

Although the Rococo was mostly French in origin, it had taken some of its inspiration from the Italians and the Flemish, especially Rubens. Its basic purpose was interior decoration. The French architects did not change their designs to suit the new mode. They remained within the standards set by the French Academy and continued the Classic-Baroque tradition.

However, during the early Eighteenth Century, French Rococo style was adopted in Germany and Austria. Architects from these countries—Von Erlach, Prandtaur, Zimmermann, and Neumann—used their own tradition of Italian Baroque and French Rococo to produce what some art historians term the finest churches in all history.

In England, the Rococo produced an ordered, logical and rational style as in works by Vanbrugh. Here, there evolved an emphasis on the Palladian Style and Classic Antique.

11.2.3 Rococo Sculpture

Sculpture during the Rococo period portrayed little figure groupings of playful, mythological themes. These, usually nude, were done in a light-hearted manner. Their gentle eroticism echoed the Baroque emotionalism of Bernini.

Rococo sculpture was designed to fit into room-size interiors rather than act as a focus in a vast structure. Busts and terracotta figurines by the Frenchman, Clodion, were popular for household decoration. Garden ornaments, ceiling carvings, etc. were also prevalent. Yet there were some monumental sculptures by the Frenchman, Falçonet that mirrored the dramatic, dynamic poses of the Baroque. And the French sculptor, Hudson, with a precise chisel carved realistic heads upon Classic Antique clothed or nude bodies such as George Washington and Franklin. His work anticipated Neo-Classical art of the early Nineteenth Century.

11.2.4 Rococo Painting

Rococo painting was dominated by three countries, Venetian Italy, France, and England.

No longer of importance either as a political or an economic power, Italy still remained the spiritual home not only of Christianity by Classicism as well. Italy retained its allure for citizens of all western countries. It was to such Italian cities as Venice that many came to seek culture. Thus, in Eighteenth Century Venice, a new art dedicated to pleasure reflected Venetian life. Here, a great variety of painting was created, portraits, historical scenes, genre themes, view or *veduta* paintings, landscapes, and decorative paintings. The most famous of these was Tiepolo. His style was typical Rococo—light colors, transparent washes, a sensation of illusionism, and figures dressed in contemporary attire. He truly personified "The Glory of Venice."

11.3 French Minor Art

In the French Rococo period, minor art was ranked equal to painting and sculpture. The combination of all three was united in the creation of significant and distinctive styles. Representative of this was the changing styles of French furniture:

1. During the French Baroque period, furniture was grand, formal and extremely ornate. Inlays of ivory, mother-of-pearl, brass, bone, etc. (this was called buhlwork after its developer, the cabinet-maker André-Charles Boulle) on ebony and other woods produced an ostentatious effect. The chair was extremely important during the Baroque, with tapestry, needle-point, brocade, and velvet used as upholstery material.

2. As the Baroque changed into the Rococo period, furniture design became lighter, less ponderous, with more asymmetrical forms. The legs of the furniture were now S-shaped (called cabriole) and the backs and arms of chairs and sofas were delicately carved and shaped. A decorative technique called ormulu (literally, "applied gold") was used to gild the wood with a more permanent coating than applied gold leaf. This was the era when silks and embroidery came into use as upholstery fabrics. Porcelain plaques were also used as inlay material.

3. After the mid-Eighteenth Century, a revival of interest in Classicism ushered in a return to Classic forms. Such pieces as beds, tables, and chairs were designed to emulate the Antique Roman style, with Classic fluting, use of leaf patterns, etc. The Neoclassic style would ultimately culminate in the Empire style during the early Nineteenth Century.

The textile industry in France had received its impetus from the French Academy during Louis XIV's reign, but it was during the Rococo period that it reached a pre-eminent position in Europe. French designs were copied by other countries. Silks, printed cottons, tapestry, carpeting, and wallpaper were all being produced in France. The most noted factory was the Gobelin, purchased for King Louis XIV by Colbert, and it employed hundreds of artists as well as artisans to produce the finest tapestries in Europe.

English minor art was not as decorative or as ornate as it was in France. During the Baroque era, the relatively simple Queen Anne and Early Georgian designs were followed in the Eighteenth Century by the designs of Thomas Chippendale. His designs were noted for their solidity (legs are firm, either square or cabriole). Chippendale decoration, though elaborate and distinctly Rococo in its carved appearance, was never done at the expense of utility. The work of the Adams brothers, who followed, was lighter and more graceful, with more of the Classic simplicity than is shown in the Chippendale pieces. Hepplewhite and Sheraton were also Eighteenth Century English cabinet-makers in the Neoclassic vein, with Sheraton's pieces a little sturdier than those of Hepplewhite, who leaned toward the fragile in his designs.

In France, the death of Charles Le Brun at the close of the Seventeenth Century brought an end to the official academic style. The French Rococo era found artists emphasizing light pastel colors, free brush strokes, and curving, graceful figures set in idyllic, pastoral settings. Love in all its light-hearted aspects was depicted, illustrating the pursuits of pleasure of the French upper classes. Thus there developed a Fêtes-Galantes style. Watteau, Fragonard, Peter, Boucher, etc. were but a few who painted pastoral gatherings of lovers. On the other hand, there were painters of the middle classes—Chardin and Greuze—whose moralistic, sentimental figure-piece themes predicted the rise of the bourgeoisis and the eventual coming of the French Revolution.

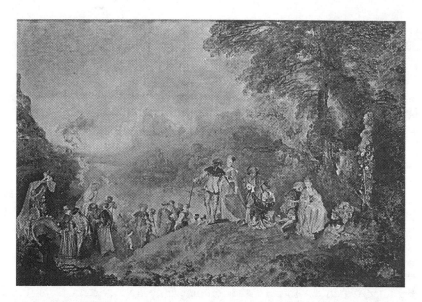

ROCOCO PERIOD: *A Pilgrimage to Cythera*, Antoine Watteau, 1717. Oil on canvas. The Louvre, Paris.

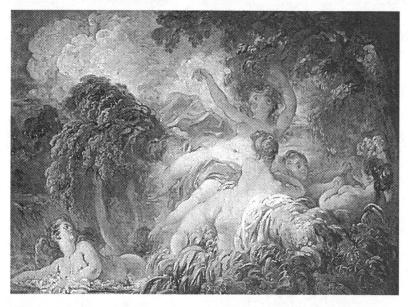

ROCOCO PERIOD: *Bathers*, Jean Honoré Frayonard, 1765. Oil on canvas. The Louvre, Paris.

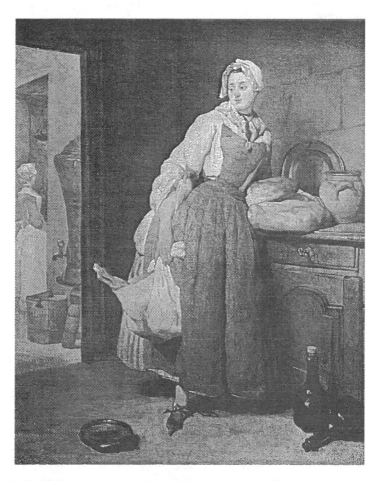

ROCOCO PERIOD: *Back from the Market,* Jean Baptiste Siméon Chardin, 1739. Oil on canvas. The Louvre, Paris.

Interest in English Rococo painting arose after the Restoration. With it, there evolved an emphasis on the one popular type of English painting—the portrait. Following the manner of the Fleming Van Dyck, English portraiture developed rapidly. Such artists as Reynolds, Gainsborough, Lawrence, and Raeburn conceived full and half-length portraits, miniatures, and even conversation pieces (groupings of figures). In addition, the social satirist, Hogarth, poked fun at the English upper classes through his oils and engravings.

CHAPTER 12

Nineteenth Century Art

12.1 Origins

The end of the Eighteenth Century found the western world racked by a series of revolutions: the American, the French, and the Industrial. Also, the decline of the aristocracy, the rise of the middle class to political and economic prominence, and the growth of an urban, rather than an agricultural society produced a change not only in society's attitude toward art, but among artists themselves.

As for academic art, it was rescued by the publication of J.J. Winckelmann's *History of Art of Ancient Times* (1764) which indicated how much Classic artists owed to the Ancient Greeks. This, coupled with new archaelogical discoveries, brought about a Neo-Classic Revival in the creative arts. Neo-Classicism was encouraged not only by the Academy but by the newly rich middle class who preferred to spend their money on a proven art.

On the other hand, an anti-academic art style that had begun to formulate itself before the end of the Eighteenth Century emerged. This was Romanticism. Romanticism had to do with the emotions and subjective thoughts. The Romantic period was a revolt of the heart against reason, of emotion against intellect, of the mysterious against the rational, of the individual against set formula, of the senses and the imagination against everything else. As opposed to Neo-Classicism, the Romantic artisan asserted that "the heart has its

reasons which reason does not know." Some say that Romanticism was a later manifestation of the Baroque, but in a more imaginative and subjective way.

A third "ism" that arose in the first half of the Nineteenth Century was Realism. In the area of architecture, it was known as Functionalism. As artists looked to real subjects from the everyday world and interpreted them as they actually were, so architects used metal (iron, cast iron, and then steel) and glass as a way to express the structural "reality" of their buildings.

Later in the Nineteenth Century, Neo-Classicism and Romanticism wained. In painting, Impressionism, Neo-Impressionism, Post-Impressionism, and Symbolism arose. In sculpture, Rodin developed a new approach to Realism. Architects further developed the possibilities of structure through the use of steel and reinforced concrete.

12.2 Nineteenth Century Architecture

Neo-Classic architecture saw the revival of Greek and Roman inspired buildings that were both spiritual and secular. In England, Lord Burlington and Kent built the first Neo-Classic work—Chiswick House. The British designer Robert Adam wrote books on the Palace of Diocletian and designed interiors that echoed Antique abodes. The German, Langhans and the American, Jefferson fashioned themes from Greek and Roman architecture.

NEO-CLASSICISM PERIOD: Thomas Jefferson. Garden Facade, 1770–1784; 1796–1806. Monticello, Charlottesville, Virginia.

Romantic architecture was first seen in the so-called Gothic Revival. Walpole and Rubinson created its initial structure, Strawberry Hill, while Barry and Pugin worked on The Houses of Parliament. Nash designed anti-Classical themes that recalled Chinese, Islamic and Hindu architecture in his Royal Pavilion in London. Garnier, the French architect, erected a Neo-Baroque ornate structure in Paris, The Opera House.

Functional architecture incorporated metals-iron, cast-iron, and later steel-and-glass. Paxton's original Crystal Palace, in London, was a virtual green-house of iron and glass. The Frenchman, Labrouste, used these new industrial materials in his libraries in Paris. Even a tower by Eiffel had a mixture of iron, and steel. The American, Richardson, used a steel cage behind masonry for his Marshall Field Wholesale Store, Chicago.

THE ROMANTIC PERIOD: *Strawberry Hill,* **Horace Walpole with William Robinson, 1749–1777. Various material. England.**

118

THE ROMANTIC PERIOD: *The House of Parliament*, Charles Barry and A. Welby Pugin, 1836. Various material. London.

12.3 Nineteenth Century Sculpture

In sculpture the first half of the Nineteenth Century was dominated by Neo-Classic and Romantic interpretations.

Houdon and Canova used a Classic style with an adaptation of the Classic technique to produce their statues that mirrored Greek and Roman models. Romantic sculpture became nationalistic in concept and eventually, by the middle decades of the Nineteenth Century, surpassed Neo-Classicism in popularity. Among the more prominent Romantics were the French artisans Rude and Carpeaux, who used monumental themes and Barye, who created a violent, unleashed energy and power through his depictios of animal combats.

At the end of the Nineteenth Century, Rodin created a realism that rivaled the art of Michelangelo and Bernini. His style predicted the advent of Modern sculpture of the next century. His figures were replete with emotion, subjectivity, and impressionistic expressionistic life force. They were sometimes even fragmented.

12.4 Nineteenth Century Painting

There developed five major categories of Nineteenth Century painting:

1. Neo-Classicism (*ca.* 1770–1820)

2. Romanticism (*ca.* 1800–1850)

3. Realism (*ca.* 1850–1880)

4. Impressionism (*ca.* 1870–1888)

5. Post-Impressionism (*ca.* 1880–1905)

Neo-Classicism reacted against the artificiality of the Rococo period. It incorporated art of Antiquity with its emphasis on historical, mythological, and heroizing current events. Its leading artists were the Frenchmen, David and Ingres.

Romanticism elaborated the emotional side of life. It revived the "dynamic-theatricality" of the Baroque with an emphasis on color and personal psychology. A flair for landscape also emerged as painters extolled the beauty of nature in monumental terms that mirrored the Dutch landscape naturalists and the art of Poussin and Claude. Noted artists were: Gericault, Delacroix, Gros, and Corot at Barbizon, France; Friedrich in Germany; and Crone, Constable, Turner, and Blake in England.

NEO-CLASSICAL PERIOD: *The Death of Socrates*, Jacques Louis David, 1787. Oil on canvas. The Metropolitan Museum of Art, New York.

120

Realist painting went against Neo-Classicism and Romanticism. Here artists portrayed life as it was, devoid of any form of ideality. In France, Courbet was its leader, followed by Daumier, the political satirist. In Spain, Goya revealed a formidable interpretation of personal characterization of subjects he knew as well as caprices in war themes, bull-fights, and quasi-surreal imagery.

Impressionism saw the interest in color and light as the subject of a painting. Scientific color theories, free brush strokes, and painting directly out-of-doors were important for them. In addition, the effects of the camera and Japanese prints also determined their mode. Among the more heralded were: Manet, Monet, Renoir, Degas, and Lautrec. Even a "spin-off" of Impressionism occurred known as Neo-Impressionism. It used broken-colors (divisionism) and dots and comma-like paint strokes (pointillism) as seen in the work of the Frenchmen, Seurat and Signac.

Finally, Post-Impressionism completed art of the Nineteenth Century. This movement developed two styles of painting:

1. An interest in the permanence of form as seen in Cezanne's geometric oriented portraits, landscapes, and still lifes.

2. The use of color, line, and pattern expressively interpreted by Van Gogh and Gaugin. They painted turgid, exotic, and psychological themes from their individual "worlds"—Van Gogh as a Dutch Modern expressionist and Gauguin as a French expatriate living in Tahiti.

The Impressionist movement lasted from about 1870 to 1885 and was centered in France. Impressionism had its roots in Realism. It emphasized light effects on objects directly taken from nature and played up optical effects within nature.

The Impressionists used quick, facile brushstrokes on the surface of the canvas to catch the transient effects of light upon an object. To reveal shadows, they used color contrasts of opposite tones (for example, red and green and purple and yellow). The Impressionists dissipated structure and lost form in a veil of shimmering color, achieving a surface rainbow effect. They cleansed color and studied the work of color-chemists and color-physicists. They developed a

scientific technique. The broken-color effect of Impressionism became a standard painting style.

Basically, Impressionism was scientific. Such physicists as Chevreul, Hemholtz, Sutter, Mitchell, and Prof. Rood (of Columbia University) were then experimenting with the natural laws of color. They observed that discs painted alternately in red and yellow, when rotated together, appeared orange. Thus, a painter could achieve the same result by placing colors side by side, for the eye blends colors. By this, a broken-color effect occurred which permitted more vibrancy of tone. The Impressionist painting's surface (because of the placing of colors side by side) becomes rough in appearance and heavy bits of paint pigment may occur. Again, conditions of light and atmosphere are revealed—a change, a feeling of time "arrested" is achieved. The Impressionists' devotion to optical truth enabled them to "catch" nature and reproduce an outdoor "feeling" on canvas.

CHAPTER 13

Twentieth Century Art to *ca.* 1950

13.1 Origins

The last decade of the Nineteenth Century saw the art nouveau (New Art) movement develop in England. Unlike the Pre-Raphaelites who preached a return to the medieval past, the Art Nouveau adherents spoke of a "new" kind of art that would come from new materials, new ornaments, and new scientific methods. Art Nouveau became especially successful in architecture and design. But in the field of painting, the change came more from the artists themselves than from new materials and methods.

The first half of the Twentieth Century saw the artist striving for personal expression, not solely in terms of the past, but in terms of his own private view of life. There arose, especially in sculpture and painting, many "isms" which symbolized different individual styles of the Twentieth Century. As a result, the Twentieth Century is best known for its "protean" or diversified nature within the creative arts.

13.2 Twentieth Century Architecture to *ca.* 1950

The word "functionalism" pertained initially to architectural concepts developed by Louis Henry Sullivan in the late Nineteenth Century. He implied that "form follows function." By this phrase, he meant that the exterior "skin" of a building showed the interior or skeleton of the structure.

TWENTIETH CENTURY: *Carson Pirie Scott & Company,* **Louis Sullivan, 1899–1904. Chicago.**

After Sullivan, the German Bauhaus School, headed initially by Gropius, furthered these concepts. This "school" produced an International Style which achieved pure, simple lines and materials that could be suitably employed to determine the basic skeleton structure—steel and glass—of a building. The phrase, "less is more," was coined by the German architect, Ludwig Mies van der Rohe who pushed to the ultimate what functionalism meant.

124

TWENTIETH CENTURY: *Seagram Building*, **Ludwig Mies van der Rohe and Phillip Johnson, 1958. New York**

There were other styles in architecture that arose. Frank L. Wright conceived Prairie Homes whose open, cross axial plans echoed the site upon which they were constructed. While Le Corbusier used a system of *beton brut* (brutalism) or textured concrete and indented windows (*brise-soleils*) all maintained by *pilotis* (pole supports for upper stories).

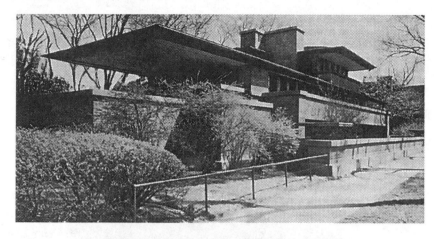

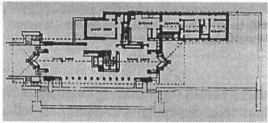

TWENTIETH CENTURY: *Robie House*, **Frank Lloyd Wright, 1909. Chicago.**

The first half of the Twentieth Century witnessed the expansion of the skyscraper in America. Such architects as Jenney, Hood, Burnham Root, and Sullivan created high-rise buildings. These exhibited structural steel, reinforced concrete, and standardized parts that were mass-produced. The elevator and technological mechanical systems came for heating and cooling. Sullivan introduced the so-called "Chicago Window" that had a fixed central glass pane and to either side double-hung windows.

13.3 Twentieth Century Sculpture to *ca.* 1950

Sculptors in the first half of the Twentieth Century either followed or protested the principles of Rodin. For example, Maillol's Classic Greek idealized formalism went against Rodin. The German

126

Expressionists, Lehmbruck and Barlach, adhered to Rodin's emotional, subjective themes.

Other styles emerged alongside these. Cubist and Futuristic sculptors such as Picasso's Boccioni dissected their quasi-abstract images. Pevsner, a Russian Constructivist, used metals and plastics to create precise, mechanistic forms. Dadism in the guise of Duchamp produced "assemblages" and "ready-mades" from discarded or nothing objects. The Surrealist Giacometti created aloof, tall figures that possessed Existentialist qualities, comparable to the writings of Jean-Paul Sartre.

13.4 Twentieth Century Painting to *ca.* 1950

Early Twentieth Century painting related to the Post-Impressionists. Fauvism, especially by Matisse, Vzaminck, and Derain, was based on pure exaltation of color and considered the first art revolution of the Twentieth Century. Concurrently, Expressionism revealed an emotional and psychological statement. Works by the Germans Nolde, Kirchner, and Beckmann constituted the present phase of Romanticism in a tragic mode. Their subjectivism expressed itself in dramatic and even obsessional themes. Meanwhile cubism was initiated by the artistic experiments of Picasso, Braque, and Gris in the first decade of the Twentieth Century. The history of Cubism falls into three phases:

1. Cezanne Phase (1907–1909)

2. Analytical (and "hermetic" phase—the abstract purification of the form) (1910–1912)

3. Synthetic Phase (beginning in 1913)

The Seurat retrospective exhibition of 1907 prepared the way for Cubism's artistic acceptance. The language of Cubism was based on order, geometry, and most importantly, simultaneity. Simultaneity was achieved through the juxtaposition of planes placed above, below, side by side, or merely superimposed on one another. It fragmented volumes into so-called little cubes or facts. Analytical Cubism broke apart and reassembled that which was faceted. Synthetic

Cubism exploited color and texture as it brought in objects from the everyday world. Cubism arrived at a fourth-dimensional effect, or what is called space-time-continuum.

From Cubism evolved the Purism or Elementarism of Mondrian and Futurism whose Manifesto extolled the intrinsic beauty of speed, power, the machine, or merely aggressive movement. Balla and Boccioni personified this style.

Dadaism developed sometime between the dispersal of Cubism (1914) and the advent of Surrealism (1915). It exploited the techniques of paper collage (pasting objects such as paper, wood, metals, etc. onto the surface of canvases). Historically, Dadaism appeared almost simultaneously in New York, Paris, and Zurich. Its roots relate, though to Zurich where, in February, 1916, at the Cabaret Voltaire (a literary club, exhibition gallery, and theater), a dictionary was opened at random by a group of intellectuals and a knife was plunged into it, striking the word "dada" (meaning hobby-horse). Dada became a cry of negation that was anti-aesthetic, anti-artistic, and anti-rational. The leader of the movement was Marcel Duchamp, followed by Francois Picabia. The movement expanded into Germany in 1918, where the social crisis of the country lent itself to its "anti" feelings and philosophy. In Berlin, Dada became political in character as seen in the work of George Grosz, a ferocious caracaturist of the German military and feudal bourgeoisie. Later, the Cologne Group, headed by Max Ernst, became involved with Dada. The Hanover Group then absorbed Dada, especially noted in the paper collages of Kurt Schwitters. Many say Dada was more of an intellectual revolt than an artistic movement, born from the unrest and political convulsions of the First World War. Whatever its meaning may have been, it soon negated itself into obscurity, only to have Surrealism build on its foundations. Some say that Dada ideas were later manifest, in American satiric Pop Art.

Surrealism, which delved into the unconscious, freed art from reason and evolved an imagery of dreams. Its artists were varied. Examples of Surrealism were Dali's absurd, ghostly Freudian symbolic images; Ernst's bizarre landscapes using a frottage (or rubbing layers of paper) technique; Magritte's sexual references; and the auto-

matic canvases of Miro with their biomorphic (life-forms), polychromatic, carnivalesque forms.

Futurism arose in Paris in February, 1909 when the Italian poet-novelist, Filippo Tommaso Marinetti published in *Le Figaro* his Futurist Manifesto. The manifesto extolled the intrinsic beauty of speed and aggressive movement. It vowed to destroy academies, libraries, and museums which taught of possessed art of the past. The ideas developed within this manifesto were, in 1910, furthered by three Italian painters: Carlo Carra, Umberto Boccioni, and Luigi Russolo. They met with Marinetti in Milan and joined their poetic and artistic thoughts. Other noted Italians who swelled the ranks of the Futurists were Giacomo Balla, and Gino Severini.

The Manifesto also praised the dynamism of modern life, emphasized the ideas of simultaneity and concerned itself with memories, free-associations and all the diverse emotions which assail an artist at the moment of creativity. It spoke of the fourth-dimension in space and quite often borrowed the style of Cubism. Many say Futurism, in spirit and style, predicted the advent of Surrealism.

Surrealism arose in Europe in 1924 with *The Surrealist Manifesto* written by André Breton. He proposed in art the unification of the subconscious with the conscious, dream with reality. Surrealism was said to have been an extension and outgrowth of Dada, but in many ways it allowed each artist to go his own way. Ultimately, Surrealism assumed two avenues of interpretation. There were those who painted realistic objects or trompe l'oeil as Giorgio de Chirico and Dali, and the so-called automatic Surrealists who abstracted the real, such as Miro, Matta, and Arp.

CHAPTER 14

Post-Modern Art: *ca.* 1950 to the Present

14.1 Origins

Post-Modern art has involved both repetition of earlier modes and a quest for innovation and creativity. Its desire, in many ways, is to break with the past and evolve its own so-called "artistic destiny." To this day, however, it is merely lip-servicing tried styles as it looks to new directions of originality.

14.2 Post-Modern Architecture

Post-Modern architecture evolved into two basic stylistic avenues. First, it showed a continuation of the International Style of the Bauhaus School, following the Miesian concepts of "less is more." Second, the emergence of individual innovators such as Louis H. Kahn who re-introduced "historical" styles and materials into his structures such as references to medieval turrets and towers. His student, Venturi actually dips into Renaissance inspired themes and is entirely anti-Mies as he asserts that "less is bore." While Rogers and Piano in their controversial Pompidou Center in Paris have created an admixture of styles and materials of this age and the past.

14.3 Post-Modern Sculpture

Post-Modern sculpture has shown signs of creativity. The American Junkyard School, headed by Stankiewitz, went to junkyards and combined discarded objects into new shapes and patterns. Pop Art sculptors—Oldenberg, Johns, Segal—created ready-mades and found-objects of all materials from metal and plexiglass to vinyl and kapok. Kinetic Art sculpture of Gabo, Pevsner, Duchamp, Moholy-Nagy—used motorized devices for their fourth-dimensional themes. While Chryssa and Raysee conceived Luminary-Art sculpture by using either highly polished metals or glass or neon and electric lights.

Minimal or Primary sculpture, sometimes called ABC Art, showed simple geometric shapes fabricated into monumental metal and fiberglass creations. Judd, Tony Smith, and David Smith followed these concepts.

Finally, Earthwork Art identified with the site. For example, Smithson furrows the landscape into geometric patterns of curves and swirls; while Christo wraps and covers cliffs and islands with brightly colored plastic to evolve a new visual concept and experience.

In addition, Alan Kaprow developed Happenings or Environmental sculpture incorporating real people and actual objects with simulated artistic imagery, and Hanson creates life-like figures out of polymer plastic.

14.4 Post-Modern Painting

With the end of World War II the art market shifted from Paris to New York. It was at this moment that Post-Modern painting began.

America now became the focal point of artistic creativity. The first style to emerge was the New York School of Abstract Expressionism. Its artists, headed by Pollock, Kline, de Kooning, and Hofmann came from all walks of life. Yet their intent was similar, that is, to create non-representational or amorphous forms and stirring colors, patterns, and designs filled with emotion and physical distortion. Sometimes called Action Painting and Cumulative Art, their techniques were bizarre as paint was thrown, spilled, or built-up upon their canvases.

There followed in the 1960s another movement called Pop Art. This style took popular, everyday images and treated them in a witty, sometimes satiric manner. Pop verged on the absurd and even poked fun at contemporary mores and institutions. The leader was Rauschenberg. He used everyday objects to create an artistic language both biting in social comment and aesthetically interesting in the use of textures, colors, and forms. Others who followed— Lichtenstein, Warhol, Rivers, Indiana—also commented on what was called "mass culture."

By the early 1970s another style emerged—Op Art. Its manner referred to those artists who used optical effects to create a new visual experience. Op paintings enticed, activated, and coerced the retina and cone to perform independently of the mind. It employed peripheral imagery, color optics, or merely black-and-white patterns. Scientific in origin, it unleashed a new, illusionistic, if not dynamic, way of seeing art. Its chief adherents were the American, Aunskiewicz, Vasarely from France, and Bridget Riley from England.

There followed on Op's heels Ob Art. Ob Art was a movement that developed in the late 1960s and continued a decade or so later. It was marked by the return of the object (or image) to the canvas. Primarily, Ob connoted figural nudity and physical activity and juxtaposition. Leading artists were Pearlstein, Leslie, Close, and Estes.

Another style that began in the 1950s and continued into the early 1980s was Color-Field painting—sometimes called Systemic or Hard-Edge Art. The manner related to pure, abstract painting in which the canvas may be blank or sections painted with bright primary colors— flatly rendered either into fuzzy edges or clearly defined borders separating these hues. Sometimes the canvas was "stained." Artists who followed this were Frankenthaler, Noland, Kelly, Louis, and Frank Stella.

Other painting styles also occurred in Post-Modern art. These echoed the Expressionists and Cubists of the early twentieth century. Truly, the cliché "What goes around, comes around" might define the final decades of the twentieth century in painting.

TWENTIETH CENTURY: *One*, Jackson Pollock, 1950. Oil on canvas. The Museum of Modern Art, New York.

TWENTIETH CENTURY: *Blue Veil*, Morris Louis, 1958–59. Acrylic resin paint on canvas. Fogg Art Museum, Cambridge, Massachusetts.

TWENTIETH CENTURY: *Empress of India*, Frank Stella, 1965. Metallic powder on canvas. Los Angeles.

MAXnotes™

REA's Literature Study Guides

MAXnotes™ are student-friendly. They offer a fresh look at masterpieces of literature, presented in a lively and interesting fashion. **MAXnotes™** offer the essentials of what you should know about the work, including outlines, explanations and discussions of the plot, character lists, analyses, and historical context. **MAXnotes™** are designed to help you think independently about literary works by raising various issues and thought-provoking ideas and questions. Written by literary experts who currently teach the subject, **MAXnotes™** enhance your understanding and enjoyment of the work.

Available **MAXnotes™** include the following:

Absalom, Absalom!
The Aeneid of Virgil
Animal Farm
Antony and Cleopatra
As I Lay Dying
As You Like It
The Autobiography of
 Malcolm X
The Awakening
Beloved
Beowulf
Billy Budd
The Bluest Eye, A Novel
Brave New World
The Canterbury Tales
The Catcher in the Rye
The Color Purple
The Crucible
Death in Venice
Death of a Salesman
The Divine Comedy I: Inferno
Dubliners
Emma
Euripedes' Electra & Medea
Frankenstein
Gone with the Wind
The Grapes of Wrath
Great Expectations
The Great Gatsby
Gulliver's Travels
Hamlet
Hard Times

Heart of Darkness
Henry IV, Part I
Henry V
The House on Mango Street
Huckleberry Finn
I Know Why the Caged
 Bird Sings
The Iliad
Invisible Man
Jane Eyre
Jazz
The Joy Luck Club
Jude the Obscure
Julius Caesar
King Lear
Les Misérables
Lord of the Flies
Macbeth
The Merchant of Venice
The Metamorphoses of Ovid
The Metamorphosis
Middlemarch
A Midsummer Night's Dream
Moby-Dick
Moll Flanders
Mrs. Dalloway
Much Ado About Nothing
My Antonia
Native Son
1984
The Odyssey
Oedipus Trilogy

Of Mice and Men
On the Road
Othello
Paradise Lost
A Passage to India
Plato's Republic
Portrait of a Lady
A Portrait of the Artist
 as a Young Man
Pride and Prejudice
A Raisin in the Sun
Richard II
Romeo and Juliet
The Scarlet Letter
Sir Gawain and the
 Green Knight
Slaughterhouse-Five
Song of Solomon
The Sound and the Fury
The Stranger
The Sun Also Rises
A Tale of Two Cities
Taming of the Shrew
The Tempest
Tess of the D'Urbervilles
Their Eyes Were Watching God
To Kill a Mockingbird
To the Lighthouse
Twelfth Night
Uncle Tom's Cabin
Waiting for Godot
Wuthering Heights

RESEARCH & EDUCATION ASSOCIATION
61 Ethel Road W. • Piscataway, New Jersey 08854
Phone: (908) 819-8880

Please send me more information about MAXnotes™.

Name _____

Address _____

City _____ State _____ Zip _____

"The ESSENTIALS" of HISTORY

REA's **Essentials of History** series offers a new approach to the study of history that is different from what has been available previously. Compared with conventional history outlines, the **Essentials of History** offer far more detail, with fuller explanations and interpretations of historical events and developments. Compared with voluminous historical tomes and textbooks, the **Essentials of History** offer a far more concise, less ponderous overview of each of the periods they cover.

The **Essentials of History** provide quick access to needed information, and will serve as a handy reference source at all times. The **Essentials of History** are prepared with REA's customary concern for high professional quality and student needs.

UNITED STATES HISTORY

1500 to 1789 From Colony to Republic
1789 to 1841 The Developing Nation
1841 to 1877 Westward Expansion & the Civil War
1877 to 1912 Industrialism, Foreign Expansion & the Progressive Era
1912 to 1941 World War I, the Depression & the New Deal
America since 1941: Emergence as a World Power

EUROPEAN HISTORY

1450 to 1648 The Renaissance, Reformation & Wars of Religion
1648 to 1789 Bourbon, Baroque & the Enlightenment
1789 to 1848 Revolution & the New European Order
1848 to 1914 Realism & Materialism
1914 to 1935 World War I & Europe in Crisis
Europe since 1935: From World War II to the Demise of Communism

WORLD HISTORY

Ancient History (4,500BC to 500AD)
The Emergence of Western Civilization
Medieval History (500 to 1450AD)
The Middle Ages

CANADIAN HISTORY

Pre-Colonization to 1867
The Beginning of a Nation
1867 to Present
The Post-Confederate Nation

If you would like more information about any of these books, complete the coupon below and return it to us or go to your local bookstore.

REA's Test Preps
The Best in Test Preparation

- REA "Test Preps" are far **more** comprehensive than any other test preparation series
- Each book contains up to **eight** full-length practice exams based on the most recent exams
- **Every** type of question likely to be given on the exams is included
- Answers are accompanied by **full** and **detailed** explanations

REA has published over 60 Test Preparation volumes in several series. They include:

Advanced Placement Exams (APs)
Biology
Calculus AB & Calculus BC
Chemistry
Computer Science
English Language & Composition
English Literature & Composition
European History
Government & Politics
Physics
Psychology
Spanish Language
United States History

**College Level Examination
 Program (CLEP)**
American History I
Analysis & Interpretation of
 Literature
College Algebra
Freshman College Composition
General Examinations
Human Growth and Development
Introductory Sociology
Principles of Marketing

SAT II: Subject Tests
American History
Biology
Chemistry
French
German
Literature

SAT II: Subject Tests (continued)
Mathematics Level IC, IIC
Physics
Spanish
Writing

Graduate Record Exams (GREs)
Biology
Chemistry
Computer Science
Economics
Engineering
General
History
Literature in English
Mathematics
Physics
Political Science
Psychology
Sociology

ACT - American College Testing
 Assessment

ASVAB - Armed Service Vocational
 Aptitude Battery

CBEST - California Basic Educational
 Skills Test

CDL - Commercial Driver's License Exam

CLAST - College Level Academic Skills
 Test

ELM - Entry Level Mathematics

ExCET - Exam for Certification of
 Educators in Texas

FE (EIT) - Fundamentals of
 Engineering Exam

FE Review - Fundamentals of
 Engineering Review

GED - High School Equivalency
 Diploma Exam (US & Canadian
 editions)

GMAT - Graduate Management
 Admission Test

LSAT - Law School Admission Test

MAT - Miller Analogies Test

MCAT - Medical College Admission
 Test

MSAT - Multiple Subjects
 Assessment for Teachers

NTE - National Teachers Exam

PPST - Pre-Professional Skills Test

PSAT - Preliminary Scholastic
 Assessment Test

SAT I - Reasoning Test

SAT I - Quick Study & Review

TASP - Texas Academic Skills
 Program

TOEFL - Test of English as a
 Foreign Language

RESEARCH & EDUCATION ASSOCIATION
61 Ethel Road W. • Piscataway, New Jersey 08854
Phone: (908) 819-8880

Please send me more information about your Test Prep Books

Name _____

Address _____

City _____ State _____ Zip _____